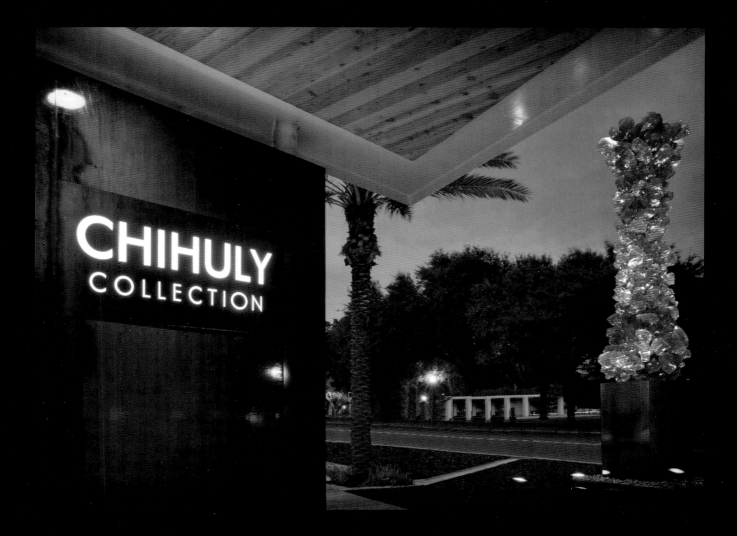

CHIHULY COLLECTION
presented by the MOREAN ARTS CENTER

Dedicated to the people of St. Petersburg

ART ENERGIZES PEOPLE. It enriches our lives through self-expression and self-discovery. It cuts across all boundaries, all age groups, all walks of life. Art reflects the best instincts of our community—its pride, vision, spirit, and generosity. It enhances tourism, stimulates economic growth, and promotes civic pride. It teaches. Entertains. Heals. Art is important for all of us.

Art is what the Morean does every day.

The Morean Arts Center, with roots dating back to 1917 as the Art Club of St. Petersburg, focuses on an innovative, community-oriented approach to art and art education. Our classes and out-reach programs are designed to bring out the artist in every soul—attracting beginners and advanced students alike.

Several years ago, our board members and supporters articulated an extraordinary vision: to bring a permanent collection of the art of Dale Chihuly to St. Petersburg, Florida. This vision is now a reality with the Chihuly Collection presented by the Morean Arts Center, located in downtown St. Petersburg. The stunning outdoor vistas complement the extraordinary art and glass installations inside. And through the faithful translation of architect Albert Alfonso, a consummate purveyor of life and practitioner of the glory of architecture, another cultural jewel has been added to our city.

The opening of the Chihuly Collection is emblematic of the world today—the project was imagined by community leaders and reimagined to fit the realities of a changing environment and economy. If, as Pablo Picasso stated, "Art washes from the soul the dust of everyday life," then Chihuly has cleansed our community with the breathtaking beauty of his creations and provided an anchor and a hub for every soul. The Chihuly Collection connects Art and Architecture, Art and Community, Art and Change, Art and Commitment. The Chihuly Collection embodies and embraces each of these pairings.

St. Petersburg's downtown waterfront is the epicenter of the city's culture, action, and beauty. The view of Tampa Bay can now be framed through the shimmering Chihuly *Florida Rose Crystal Tower*—the marker, the beacon, the iconic image for fresh ideas and beautiful aesthetics. It is the invitation to take a deeper dive through the portal of art and discover the alchemy of Dale Chihuly.

Every life—your life—deserves art.

Katee Tully
Executive Director
Morean Arts Center and Chihuly Collection

THE ART OF BUILDING A BETTER COMMUNITY

Alberto Alfonso and Katee Tully

MY FIRST ENCOUNTER with the artist Dale Chihuly occurred during a jet-lagged Seattle afternoon more than five years ago. Subsequently, I was hired by the Morean Arts Center to design a new space to house a large permanent collection of the artist's glass. At the time, we all felt there was no limit to what we could accomplish. Dale was coming to St. Petersburg, and the atmosphere was electric.

As I sat with Dale that first day, it became very clear that our journey would be a collaborative one and that he was completely infatuated with architecture and design. We discovered our mutual love for Italy and its culture of design, and we talked well into the night discussing the works of Le Corbusier, Louis Kahn, Tadao Ando, and Carlo Scarpa.

I would spend the next several years getting to know the art of Dale Chihuly and, more importantly, the driving intellect behind his process. I learned that he is comfortable with ambiguity and that intuition is a weapon he has wielded time and time again. However, the quality that most intrigued me was his tireless passion to create a synthesis between art and architecture. The objects and the space were to be indivisible—a fusion of light and shadow, color and material, reflection and instinct, expansion and contraction, intimacy and heroism.

The project's overall vision expressed and pushed four strategies: a deliberate shift in scale from one gallery experience to the next; the insertion of transitional portals between galleries to reinforce the spatial compression/expansion experience; rigorous investigations of material palettes that would support the individual architectural plans; and the interplay of light, materials, and glass to present the art in, and respect, the spirit from which it was created.

I immediately saw an extraordinary opportunity to create an architecture of procession that would allow the visitor to experience Dale Chihuly's vastly diverse art forms as a dream sequence. The journey begins with Chihuly's *Baskets* and a presentation that refers to an early Chihuly exhibition from the 1970s, as well as a superb group of drawings illuminating the artist's creative process. Continuing into and through the spaces, the viewer experiences four decades of Chihuly's brilliant series: *Seaforms*, *Venetians*, *Persians*, *Macchia*, *Ikebana*, a *Persian Ceiling*, a *Niijima Float Boat*, three *Chandeliers*, a *Neon Tumbleweed*, and *Mille Fiori*.

It truly was a remarkable experience to collaborate with Dale Chihuly, one of America's great contemporary artists and innovators, and bring his spectacular glass sculptures to an enthusiastic audience at the Chihuly Collection presented by the Morean Arts Center.

Alberto Alfonso, AIA

THE CHIHULY COLLECTION: ARCHITECTURAL REFLECTIONS

BASKET DRAWINGS

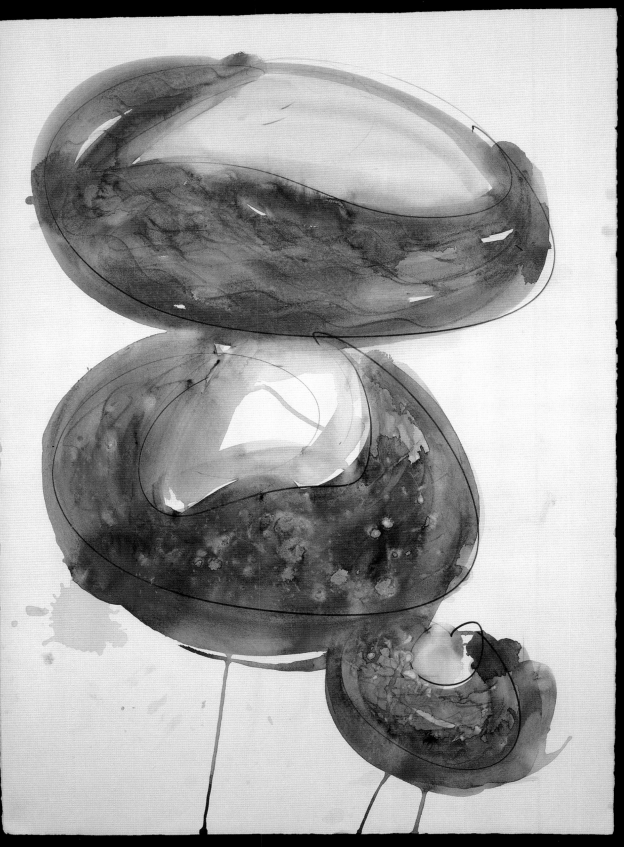

Baskets Drawing
1982, 30 x 22"

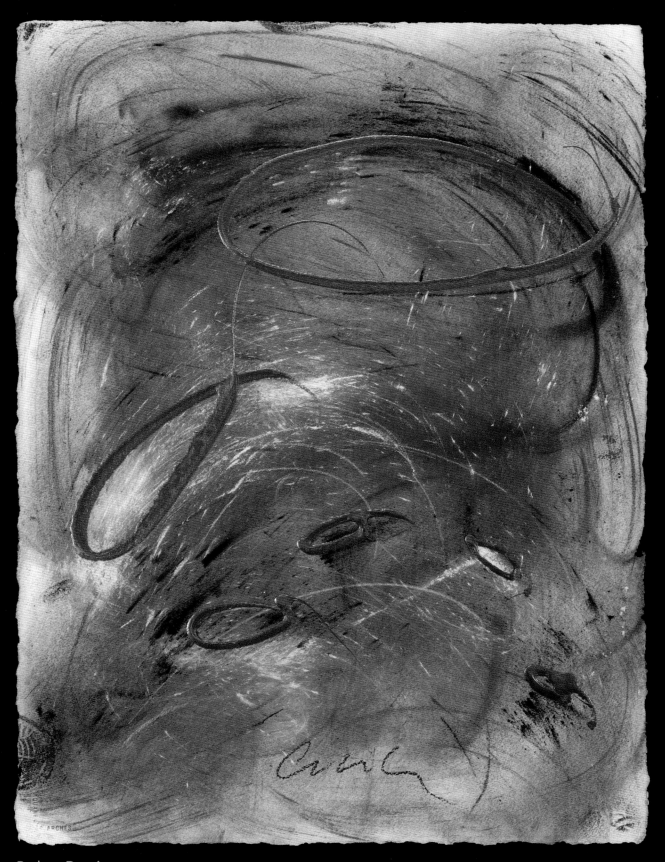

Baskets Drawing
2009, 30 x 22"

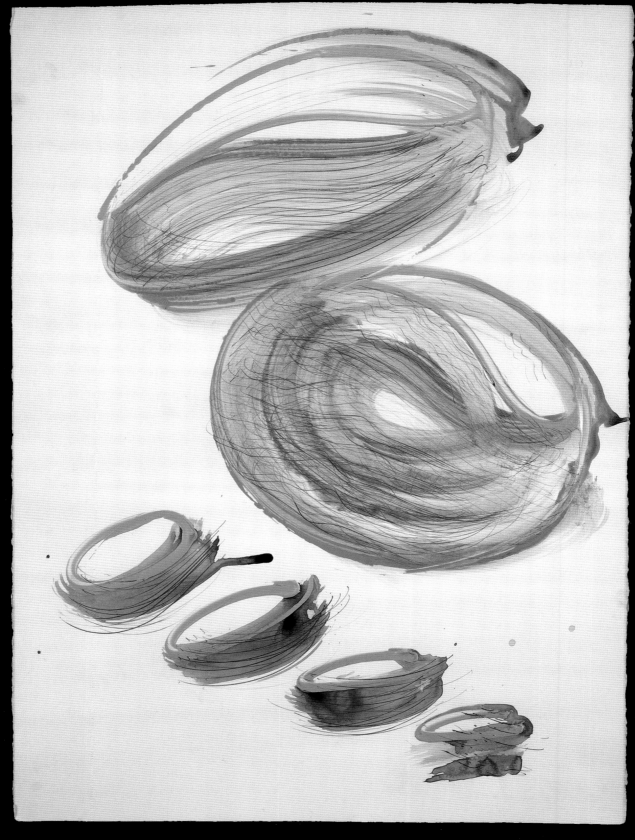

Baskets Drawing
1982, 30 x 22"

Museum of Glass Burned Baskets Drawing
2006, 30 x 22"

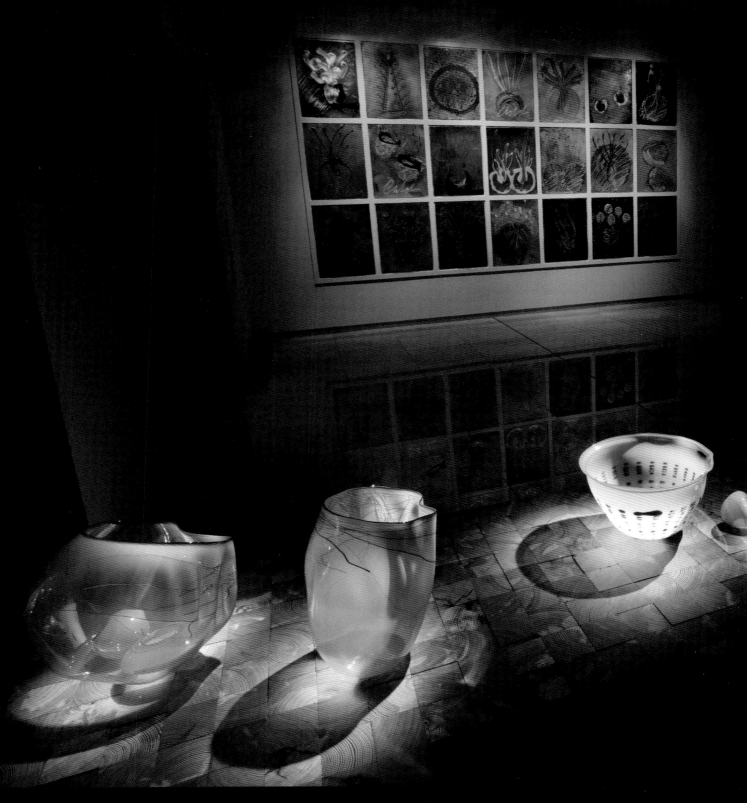

Baskets, Drawing Wall
2010

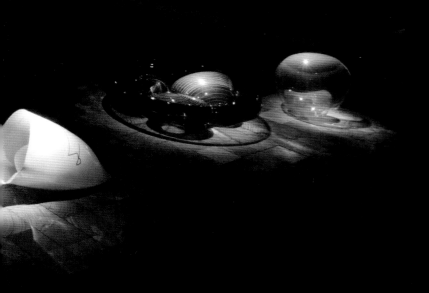

BASKETS

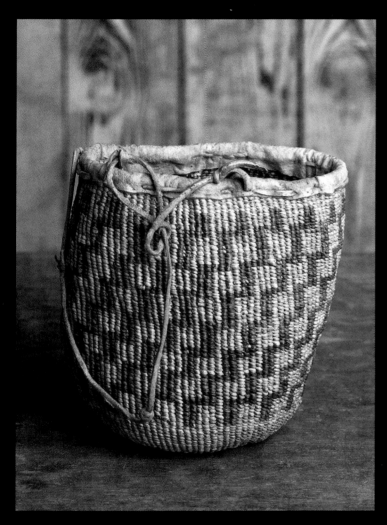

Wasco Basket
Mid-Columbia River, circa 1890, 4 x 4 x 6"

Haida-Tlingit Basket
Alaska, circa 1890, 10 x 10 x 10"

**Tabac Basket with Drawing
Shard and Oxblood Body Wrap**
2008, 14 x 10 x 11"

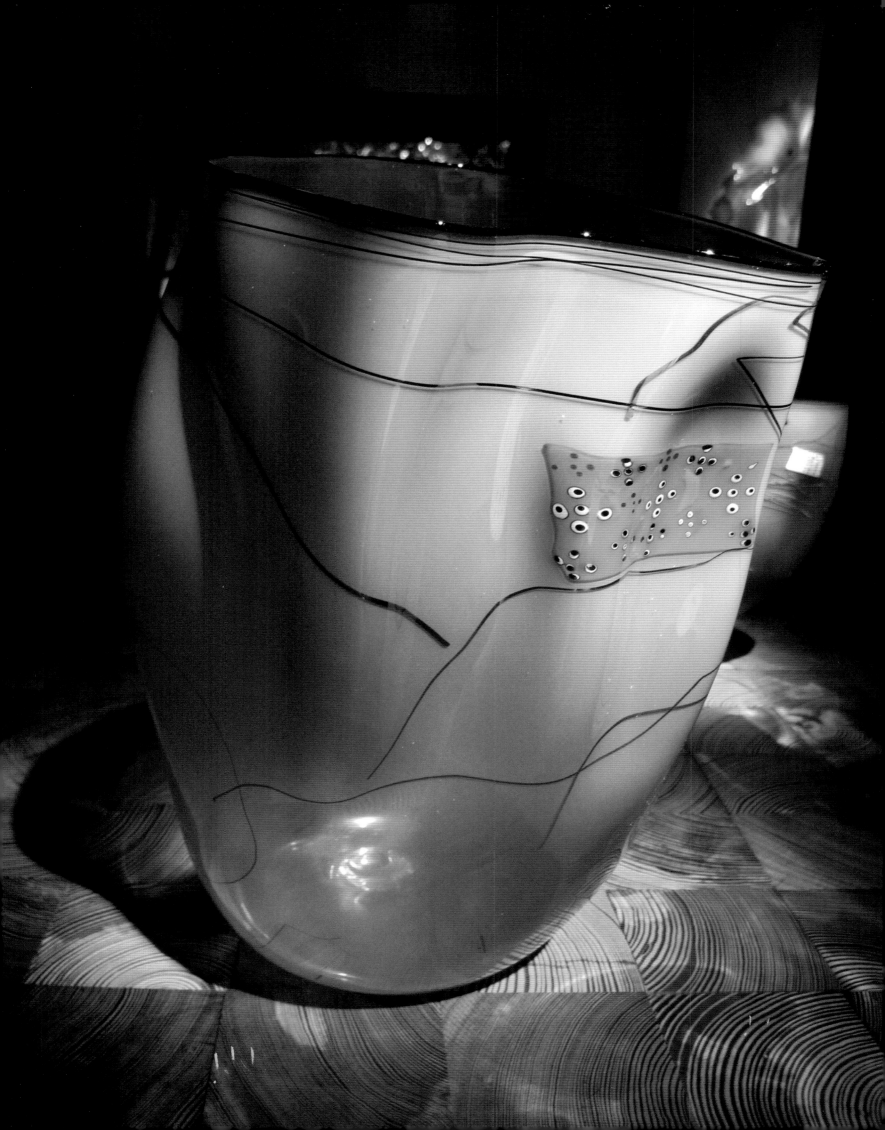

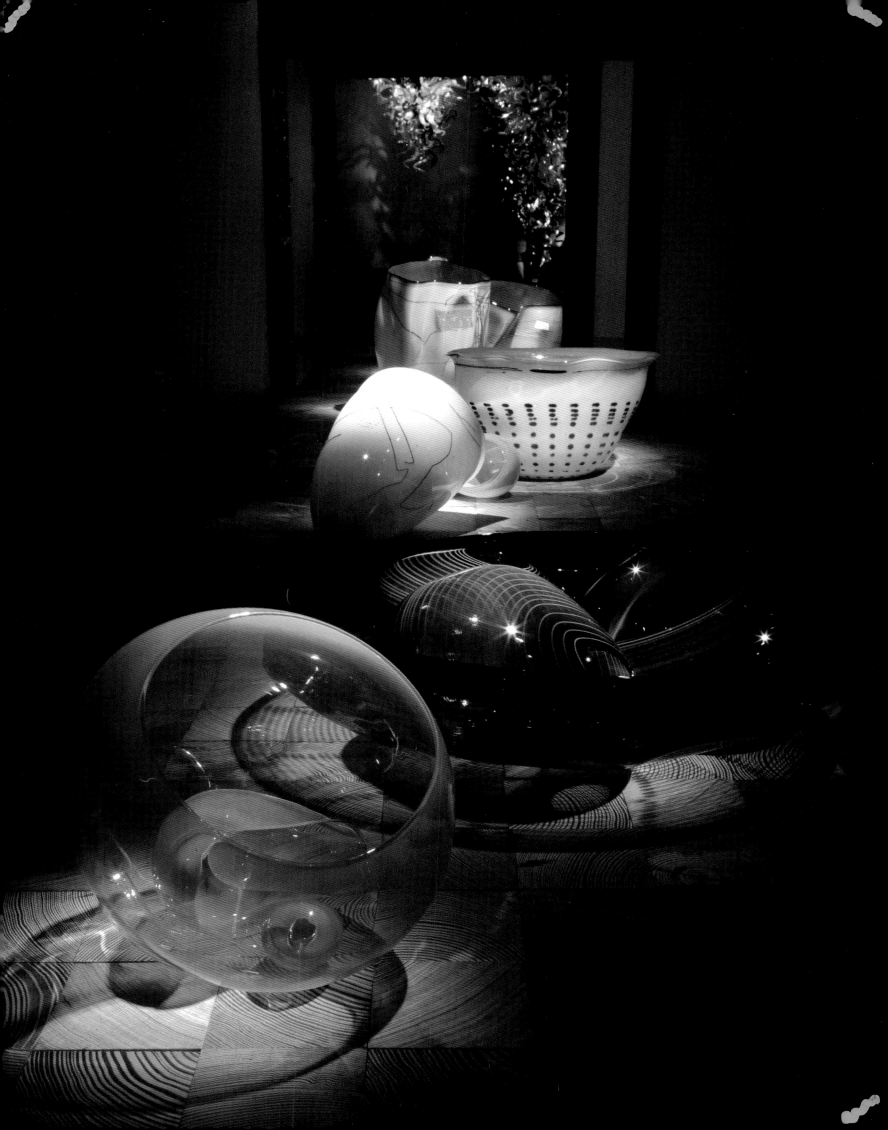

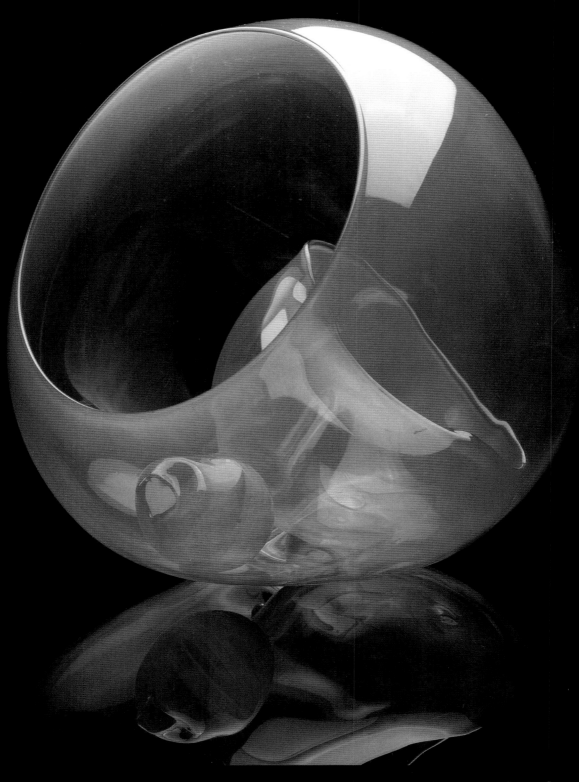

Transparent Dusty Orange Basket Set
1979, 10 x 9 x 9"

Baskets
2010

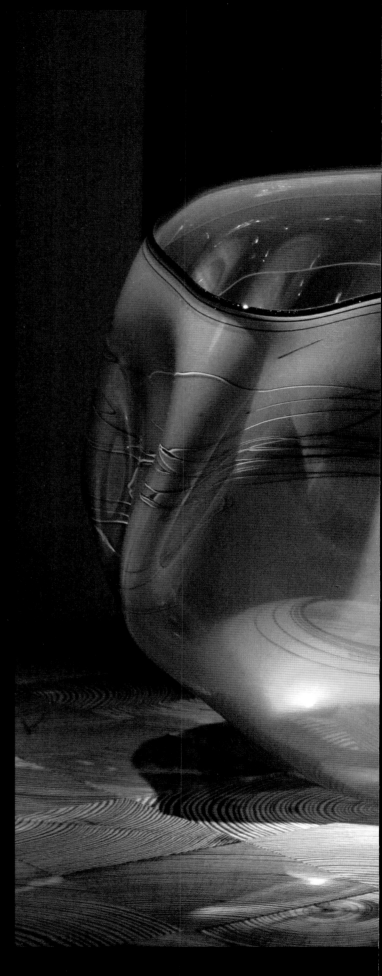

Baskets
2010

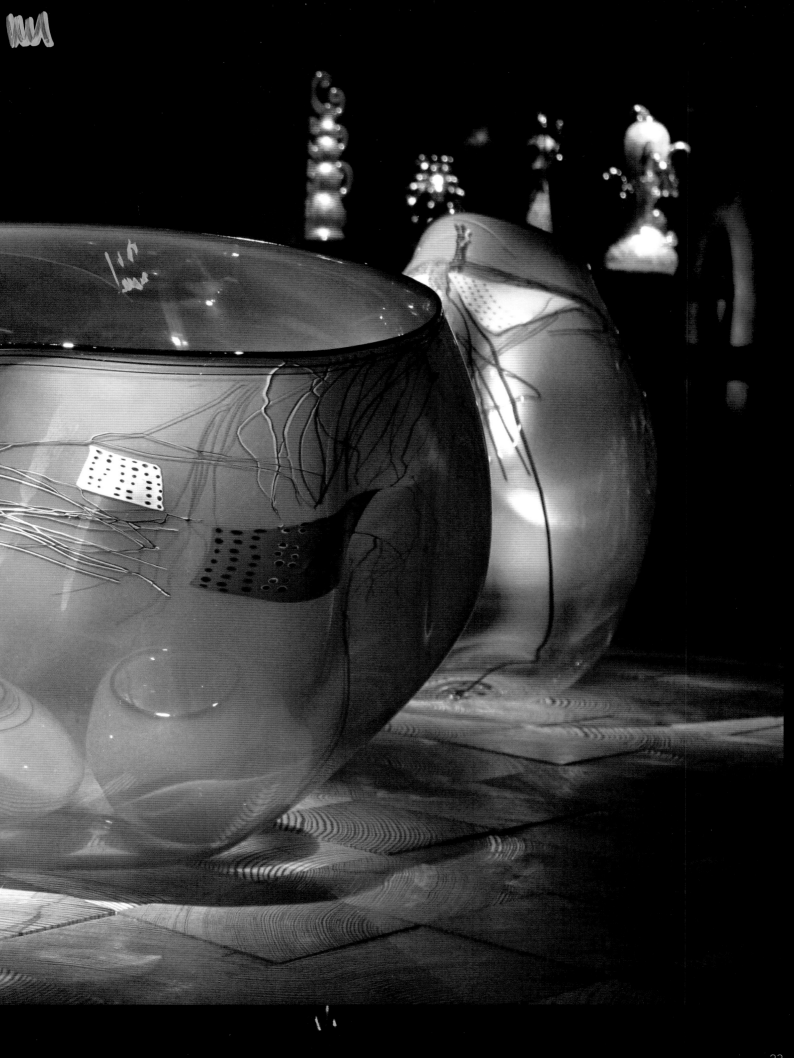

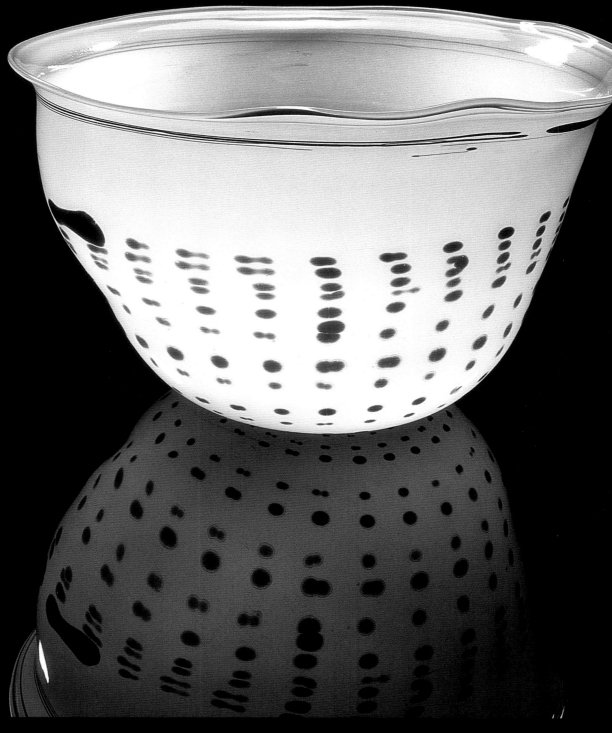

Ivory Basket with Oxblood Spots
1977, 9 x 14 x 14"

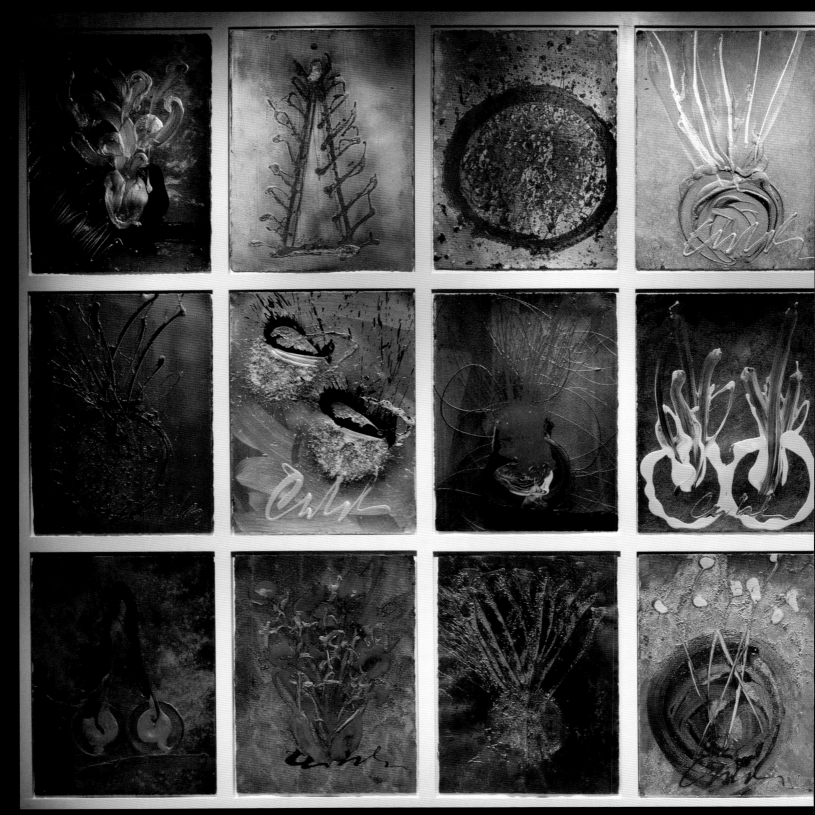

Drawing Wall
2010

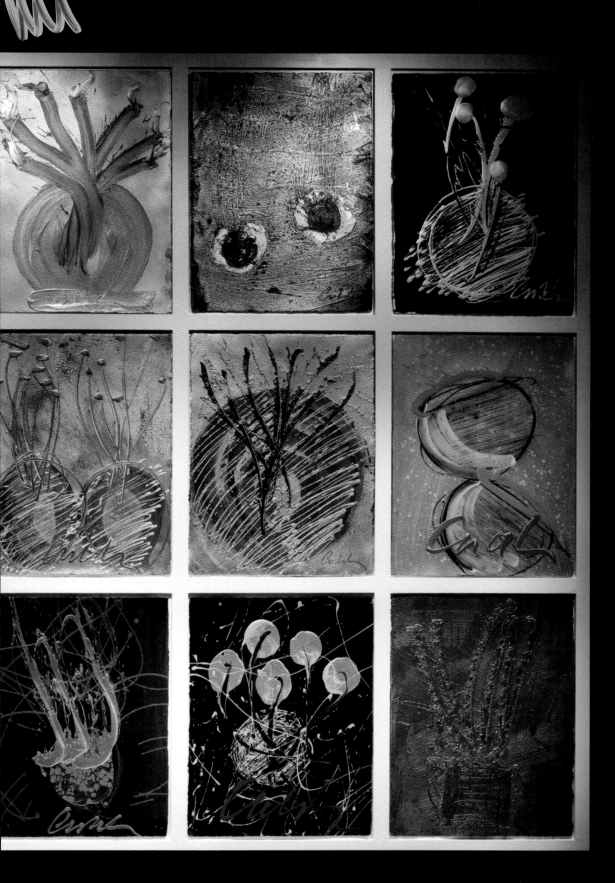

DRAWING WALL

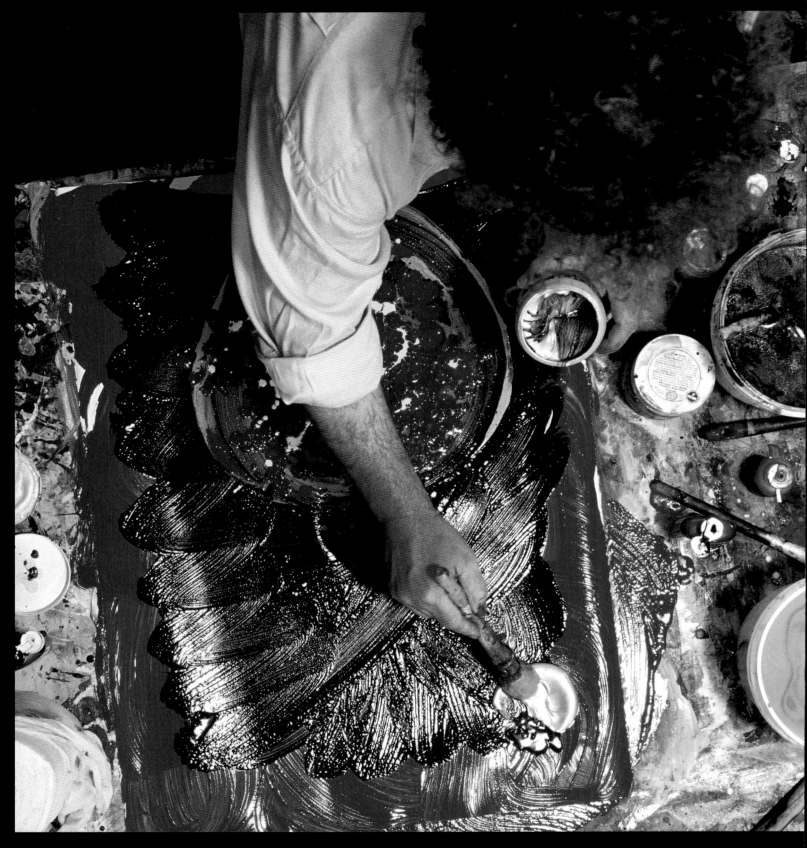

Dale Chihuly painting
The Boathouse, Seattle, Washington, 1991

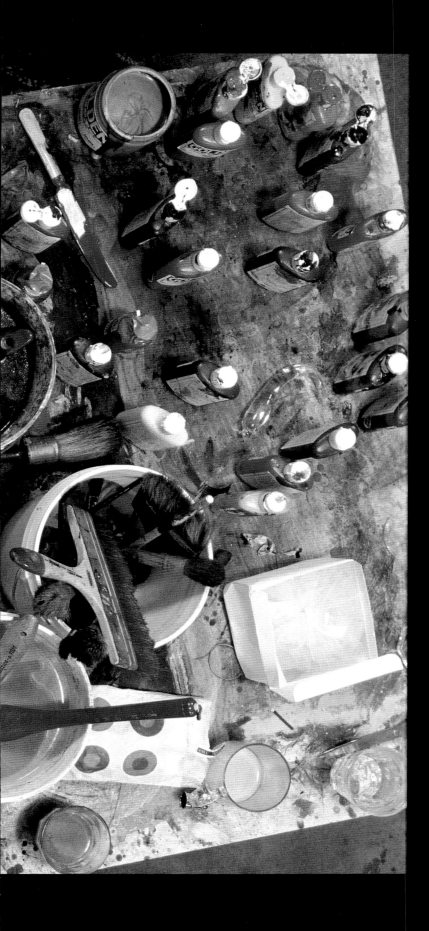

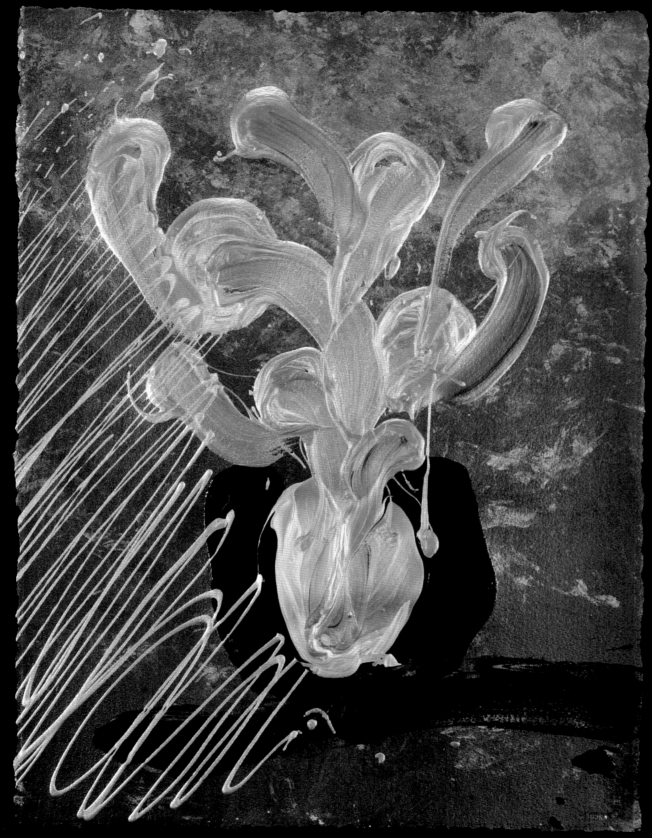

Gold and Aegean Blue Ikebana Drawing
2008, 30 x 22"

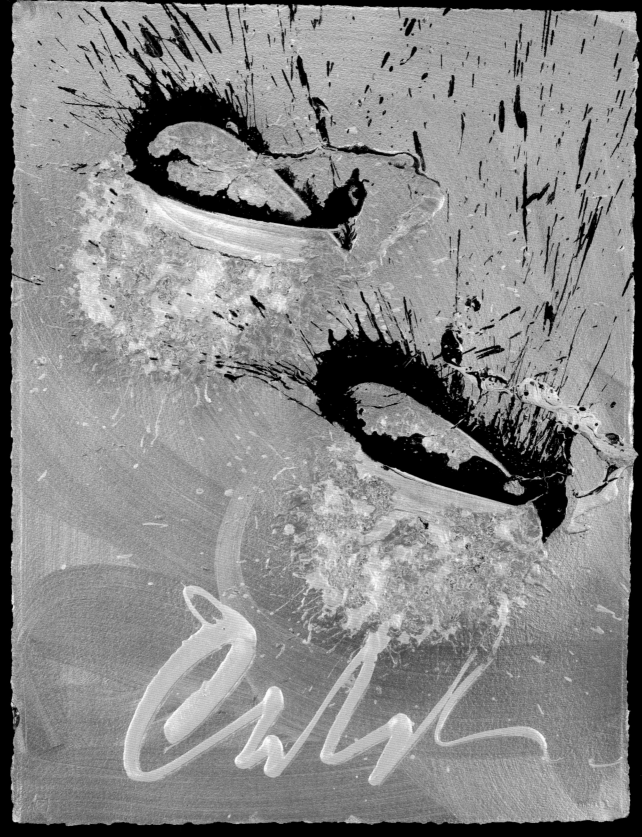

Antique Gold Baskets Drawing
2008, 30 x 22"

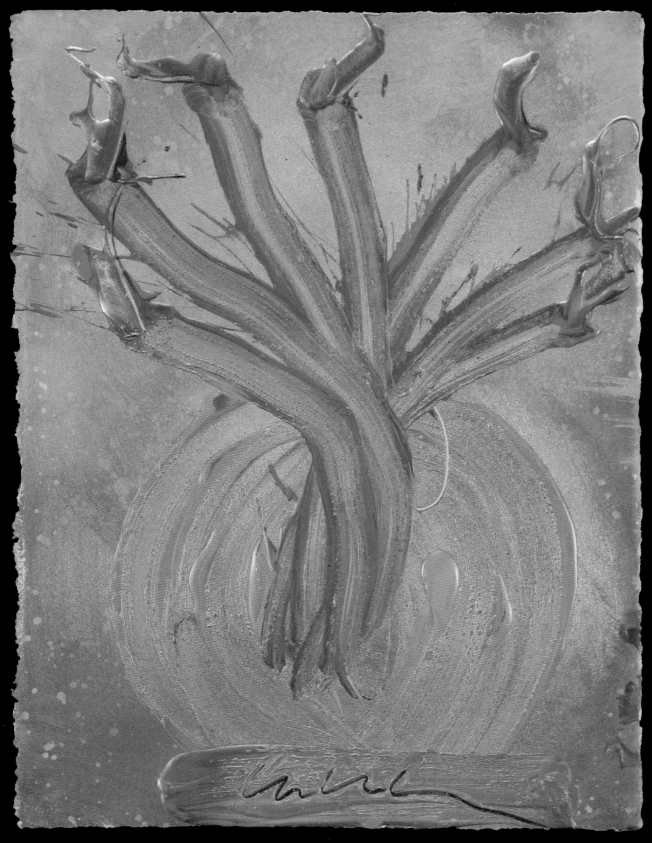

Bonfire and Jade Ikebana Drawing
2008, 30 x 22"

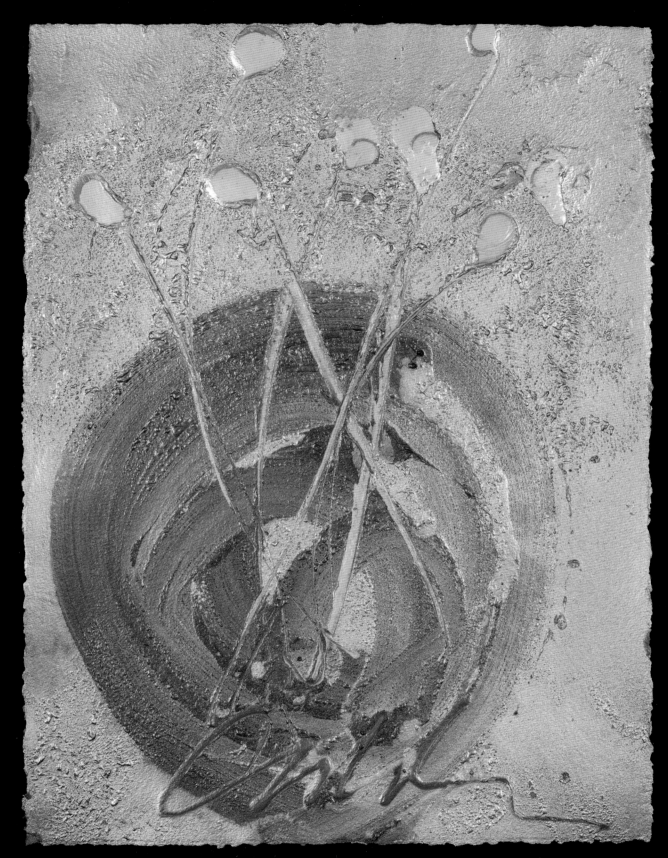

Gold and Citron Ikebana Drawing
2009, 30 x 22"

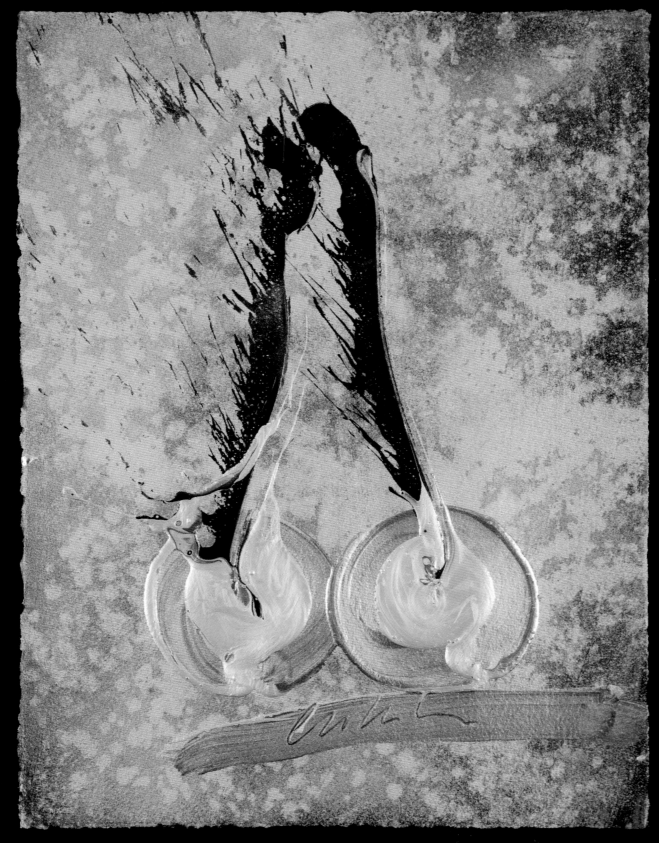

River Green Ikebana Drawing
2008, 30 x 22"

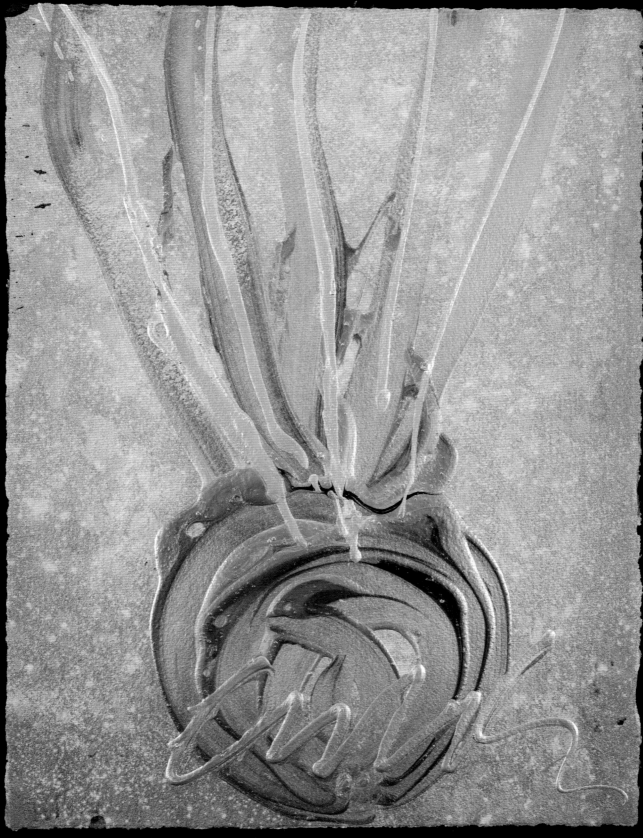

Pewter and Gilded Ikebana Drawing
2008, 30 x 22"

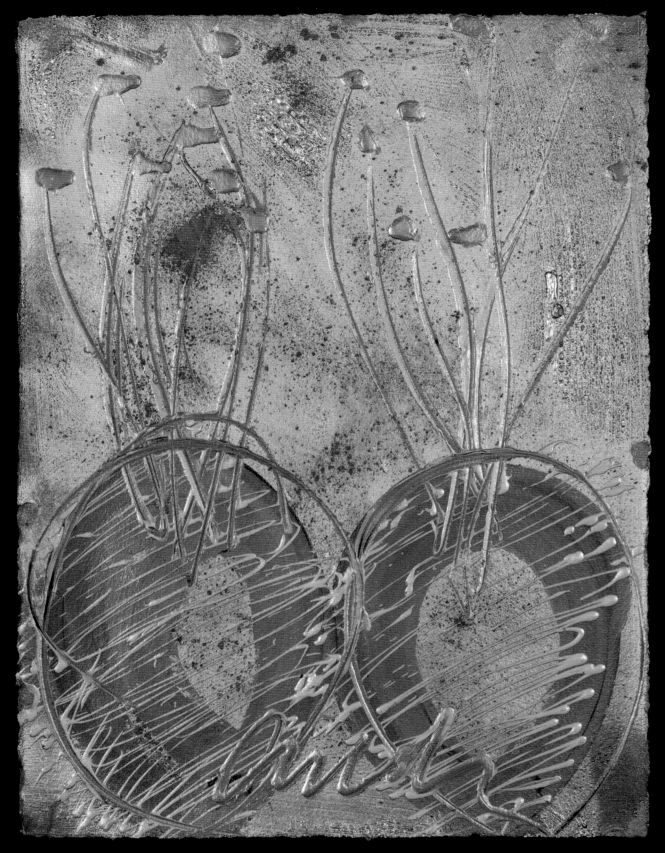

Amethyst and Gold Ikebana Drawing
2009, 30 x 22"

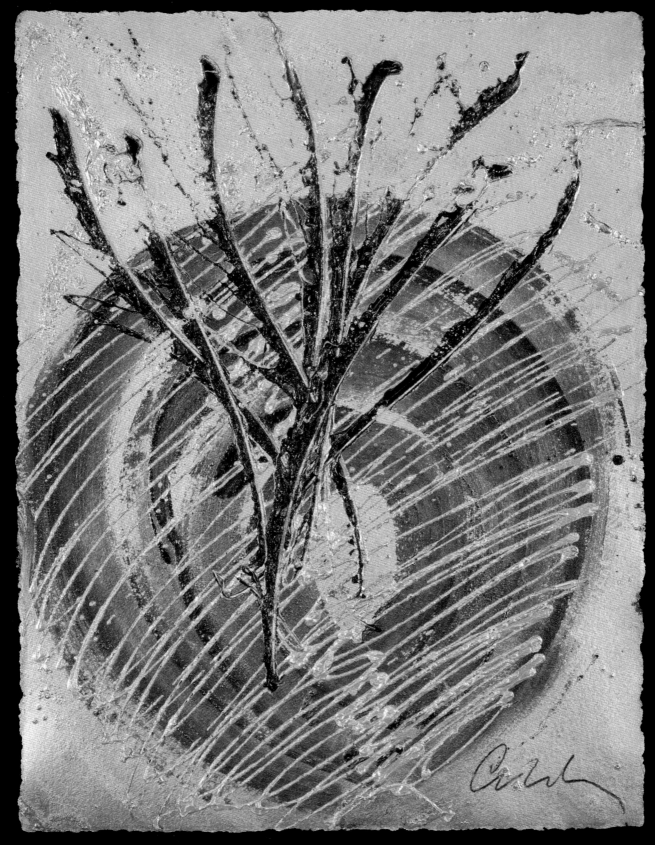

Onyx Ikebana Drawing
2009, 30 x 22"

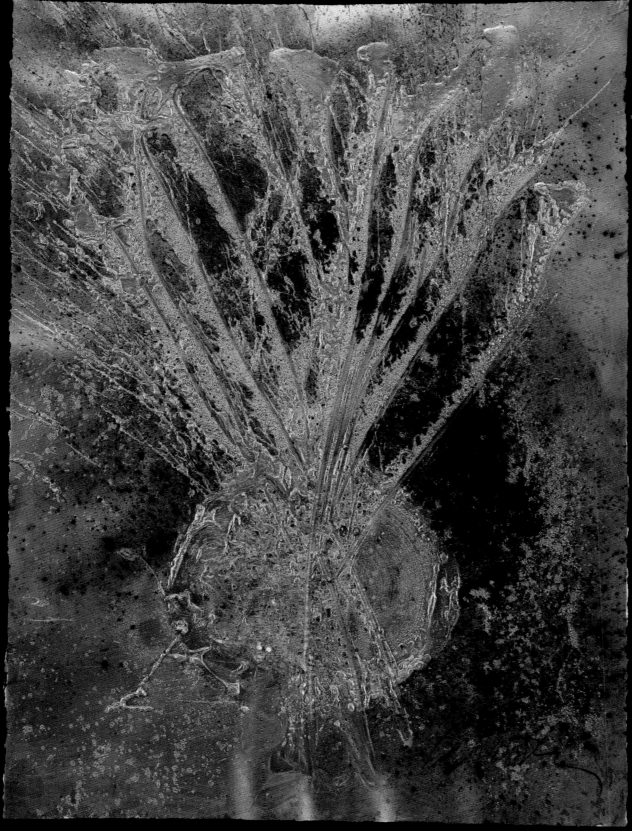

Vintage Gold and Copper Ikebana Drawing
2007, 30 x 22"

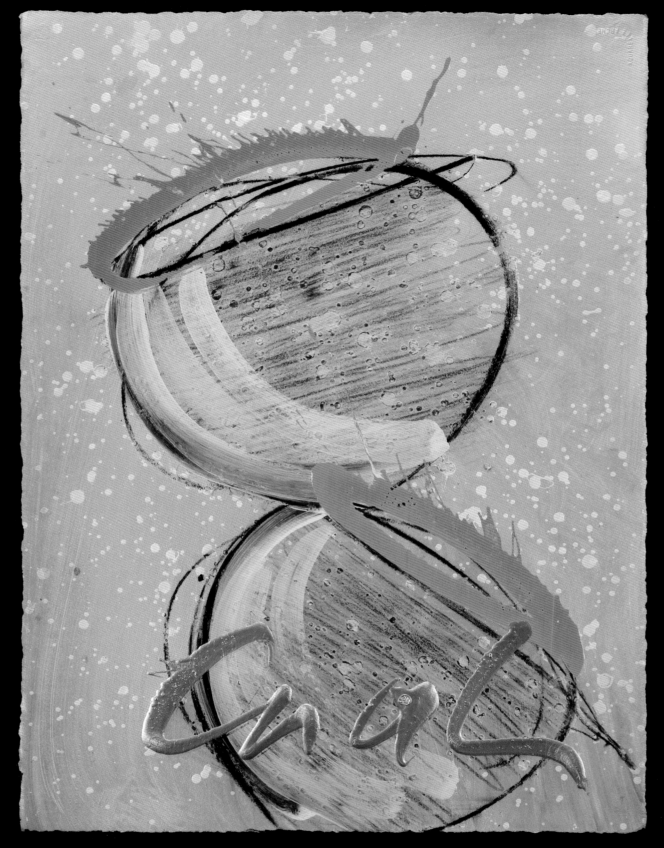

Gold and Orange Baskets Drawing
2008, 30 x 22"

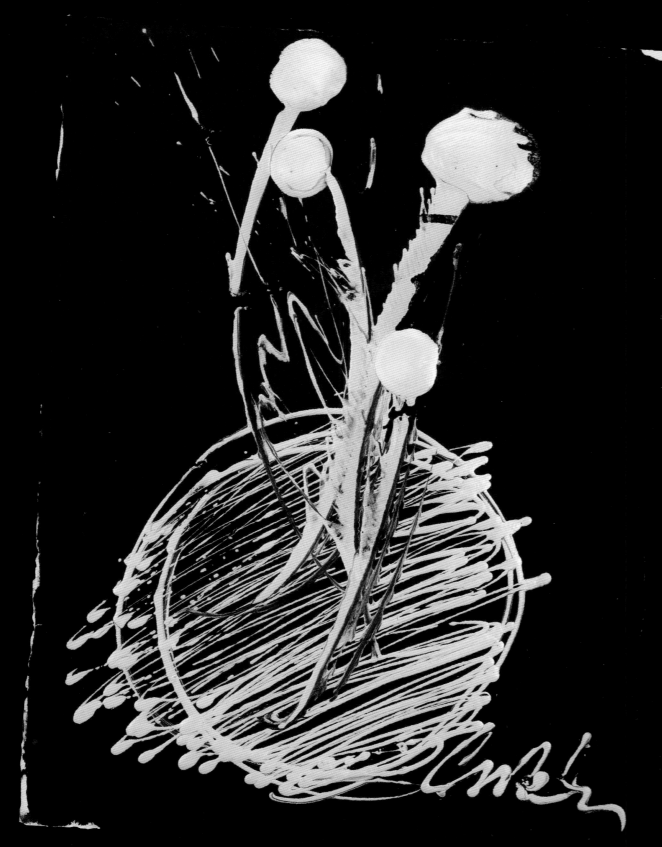

White Ivory Ikebana Drawing
2008, 30 x 22"

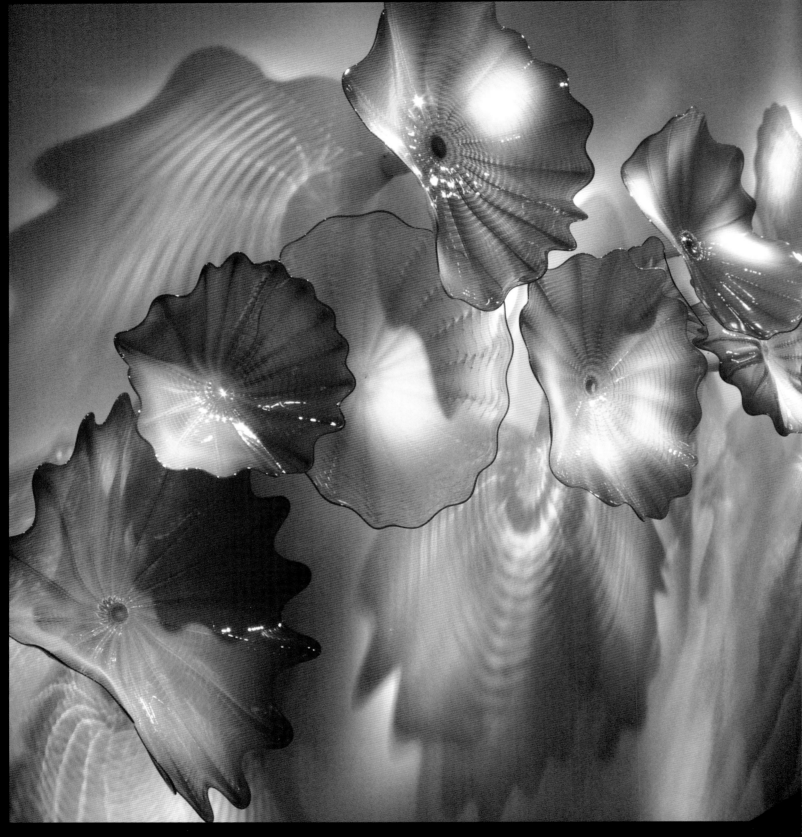

Sunset Persian Wall
2010, 6 x 25½'

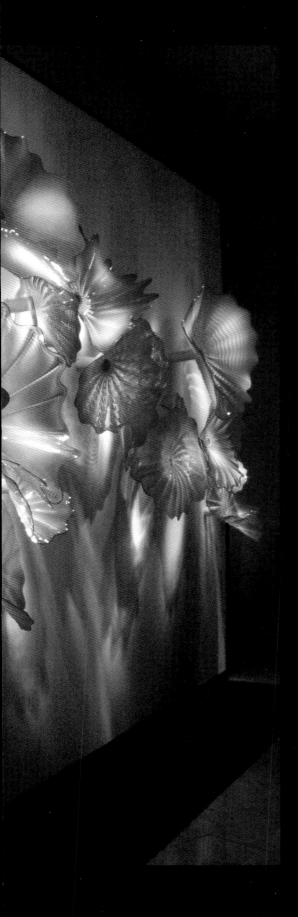

PERSIAN WALL

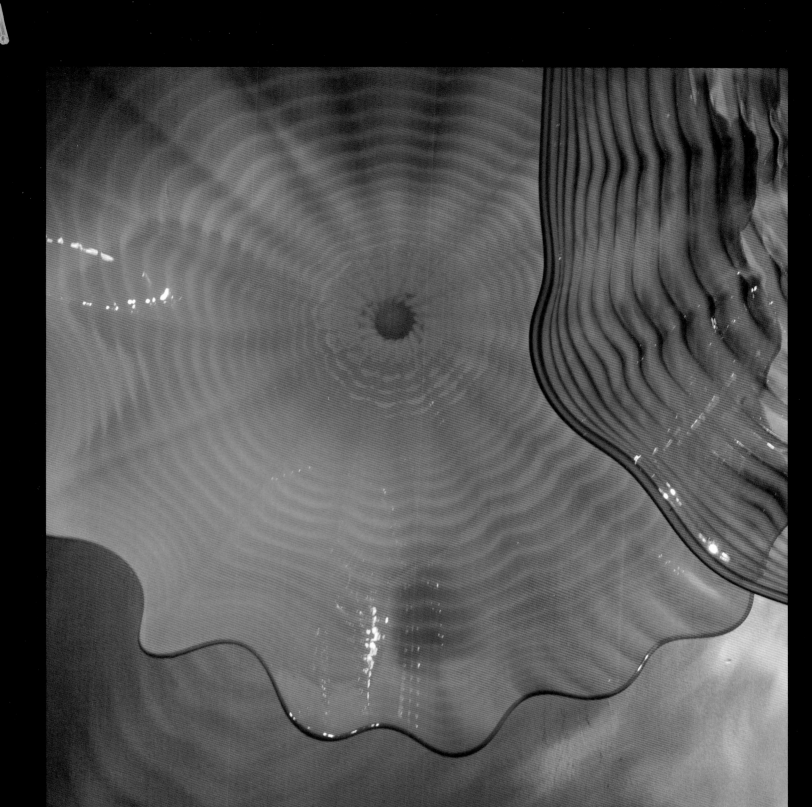

Persian Wall (detail)
2010

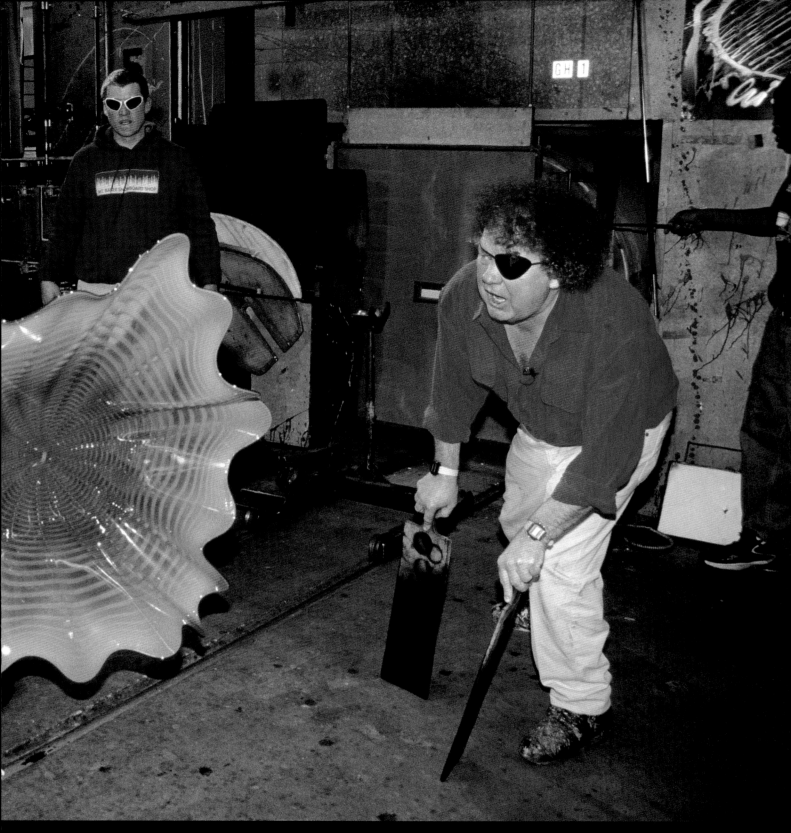

Artist Dale Chihuly with gaffer James Mongrain and Eric Pauli
The Boathouse hotshop, Seattle, Washington, 2000

VENETIANS

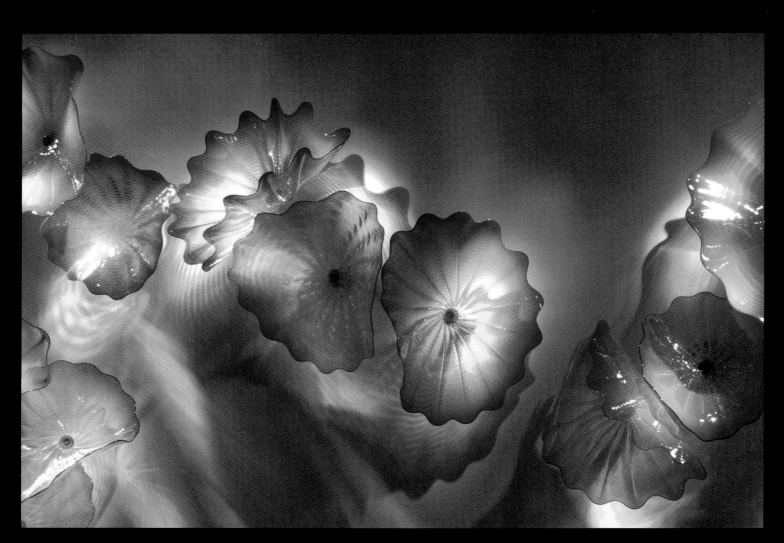

Sunset Persian Wall (detail)
2010, 6 x 25½'

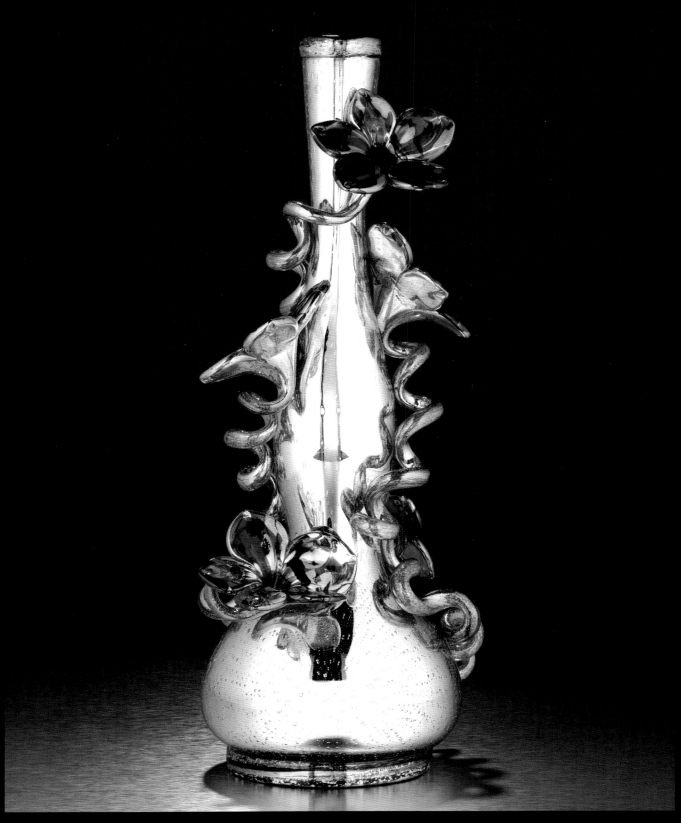

Silvered Piccolo Venetian with Teal and Aqua Spotted Flowers
2009, 18 x 9 x 7"

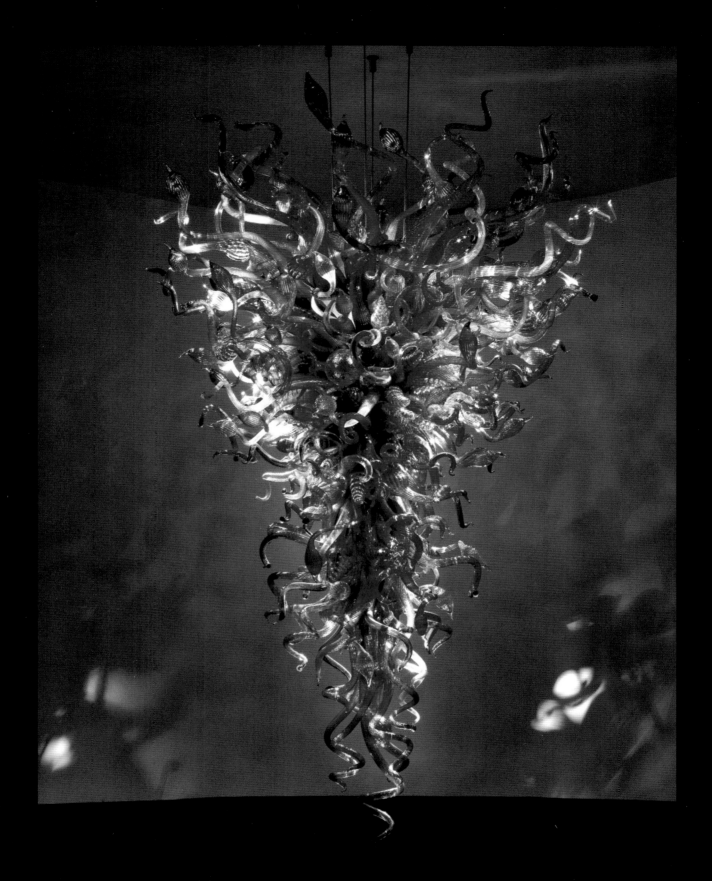

Azul de Medianoche Chandelier
2010, 10 x 6 x 6'
Gift of Joan Stonecipher

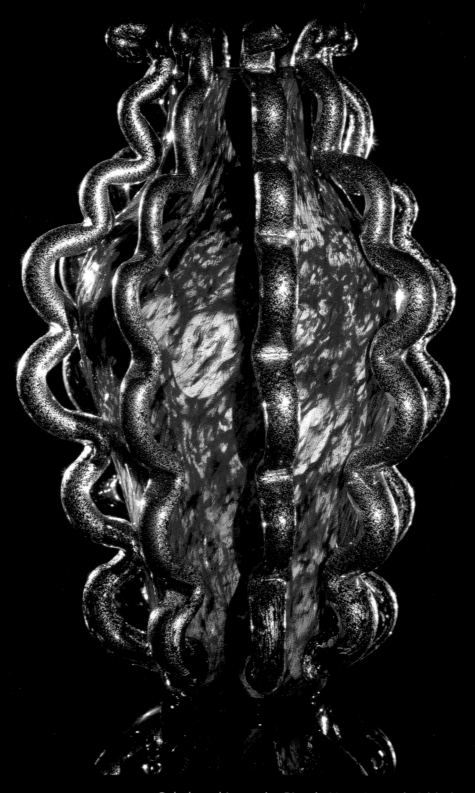

Cobalt and Lavender Piccolo Venetian with Gilded Handles
1993, 8 x 6 x 6"

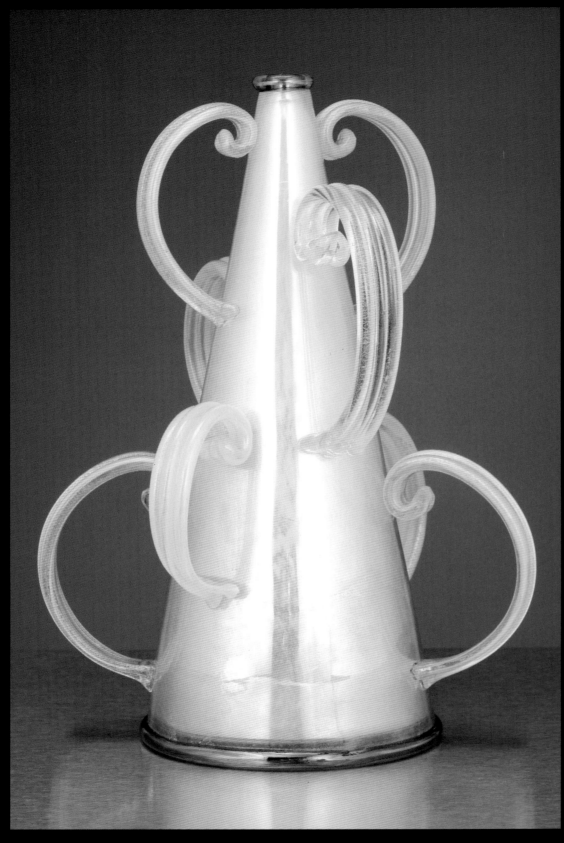

Silvered Gilded Lemon Piccolo Venetian with Curling Fronds
1999 / 2009, 12 x 8 x 8"

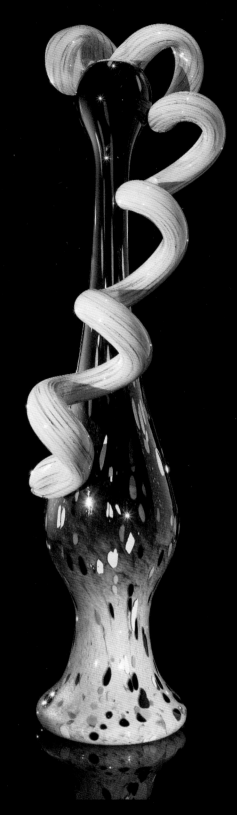

Black over Orange Venetian with Chartreuse Coil
1991, 35 x 13 x 10"

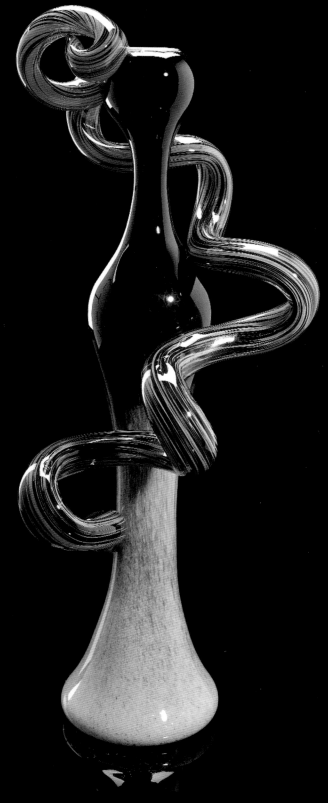

Chartreuse and Black Venetian with Orange Coil
1991, 30 x 13 x 12"

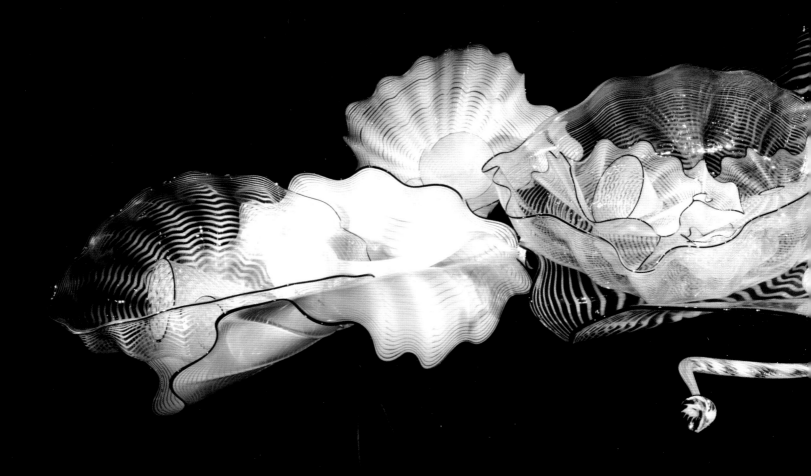

Morean White Seaform Set
2010, 15 x 96 x 36"

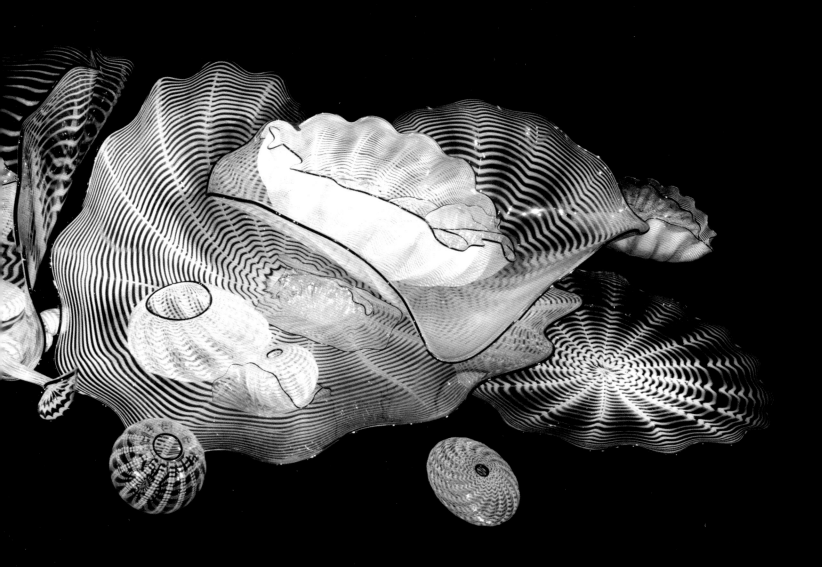

SEAFORM SET

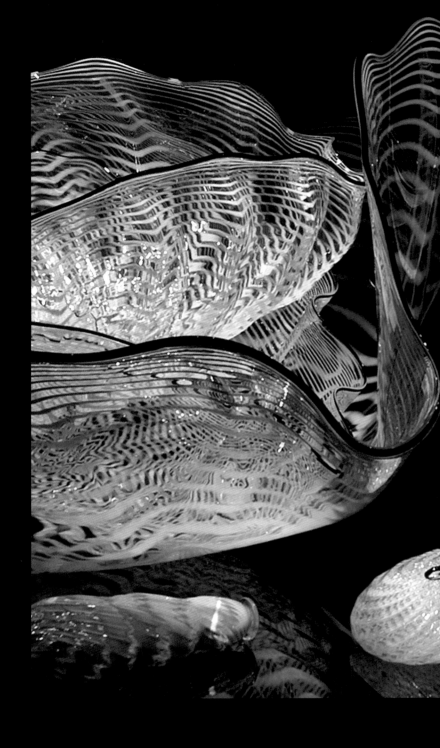

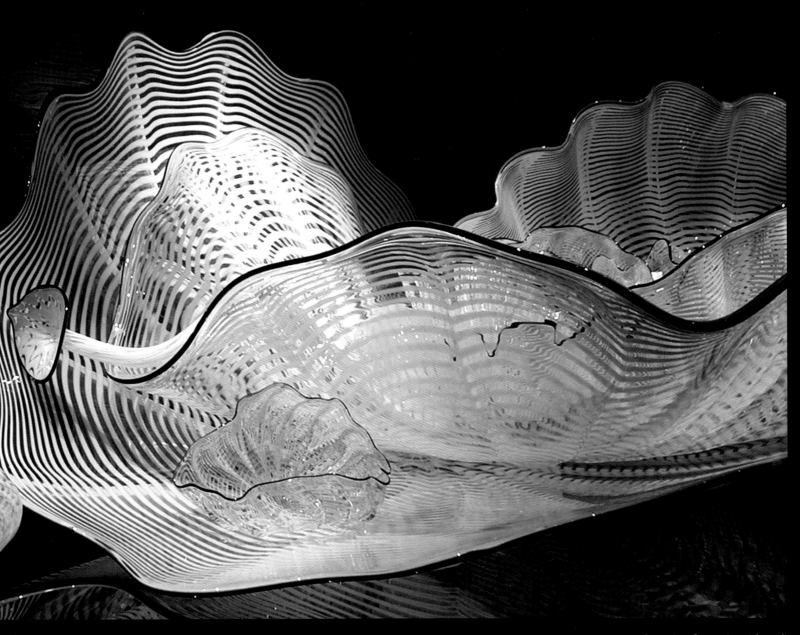

Morean White Seaform Set (detail)
2010, 15 x 96 x 36"

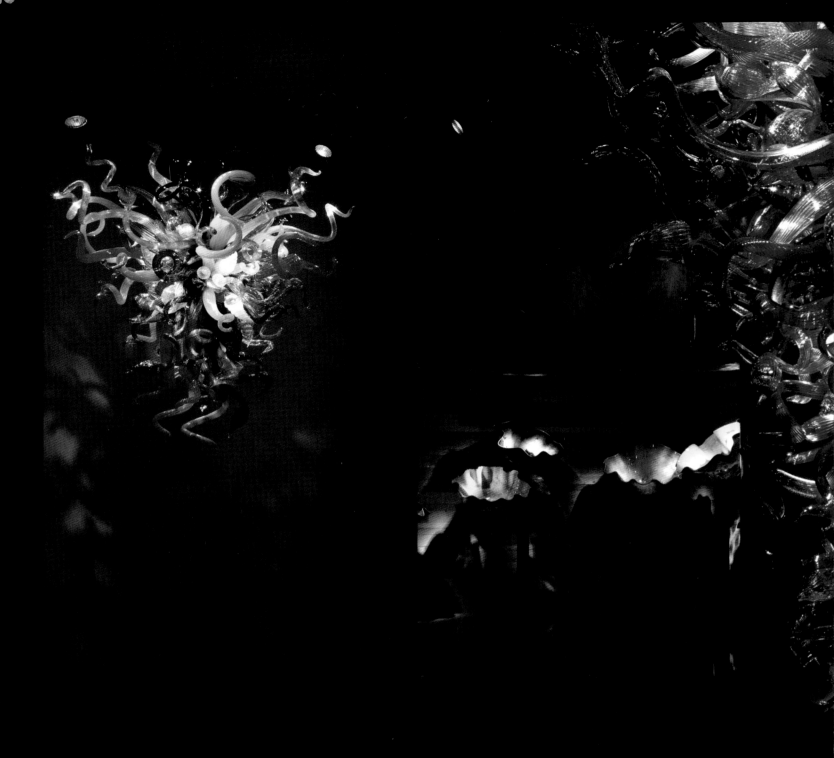

Chandeliers, Macchia Forest
2010

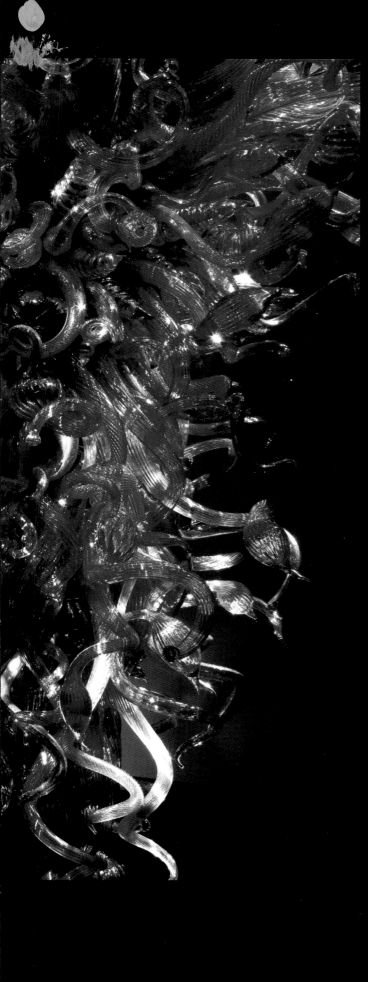

CHANDELIERS

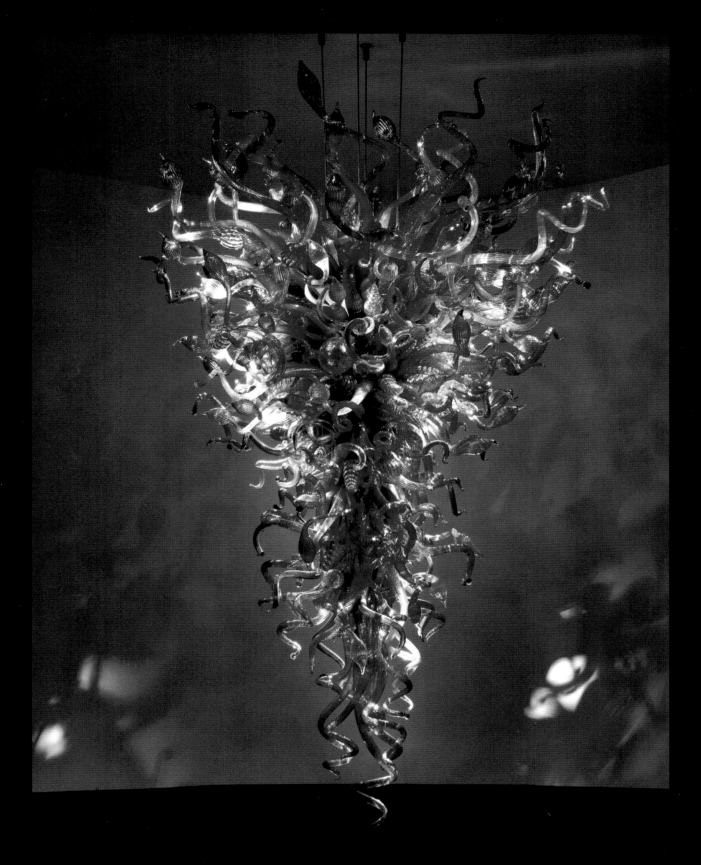

Azul de Medianoche Chandelier
2010, 10 x 6 x 6'
Gift of Joan Stonecipher

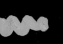

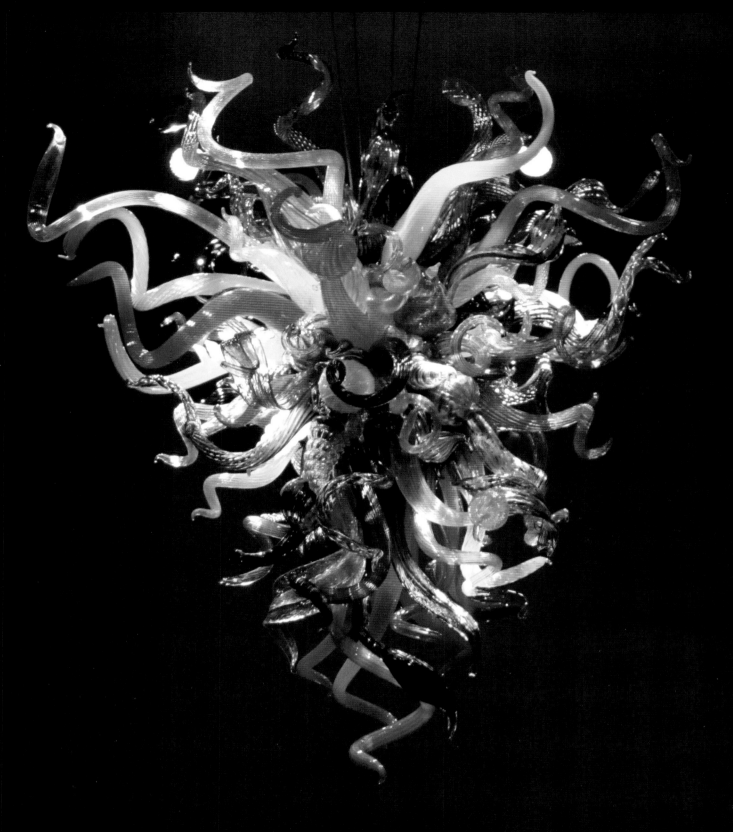

Carnival Chandelier
2010, 5 x 4½ x 4'

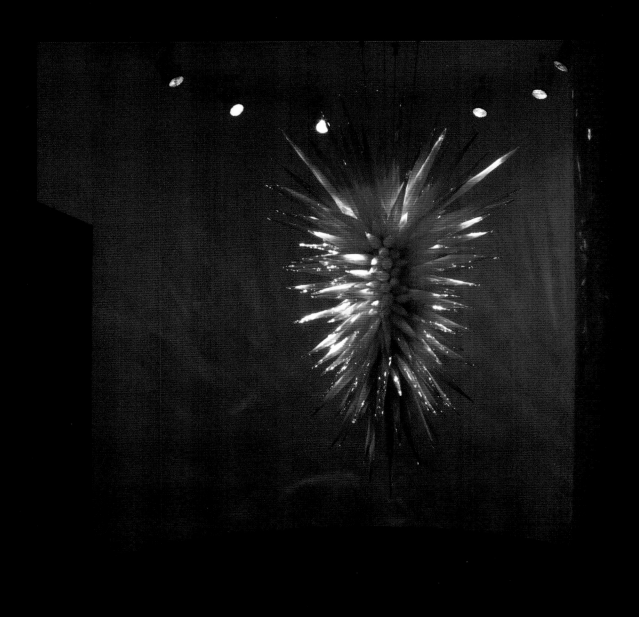

Ruby Red Icicle Chandelier
2010, 8 x 5 x 5'

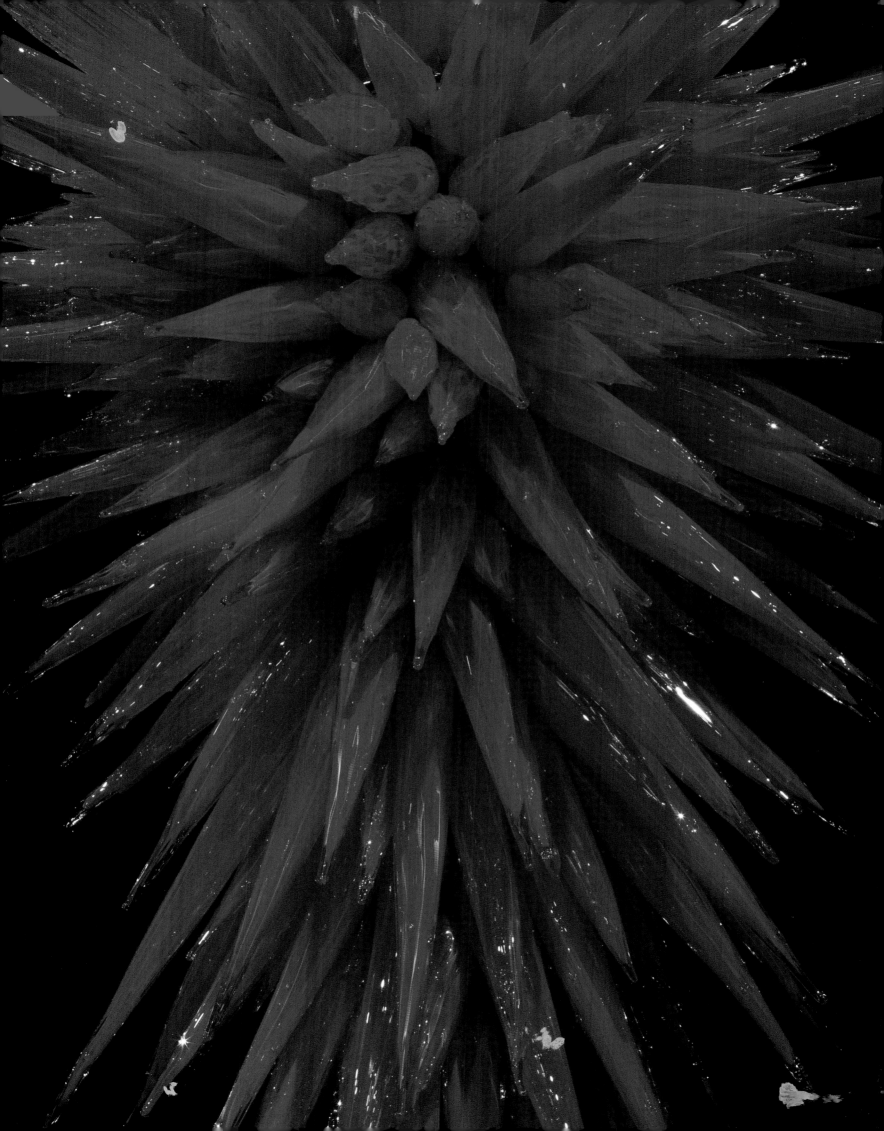

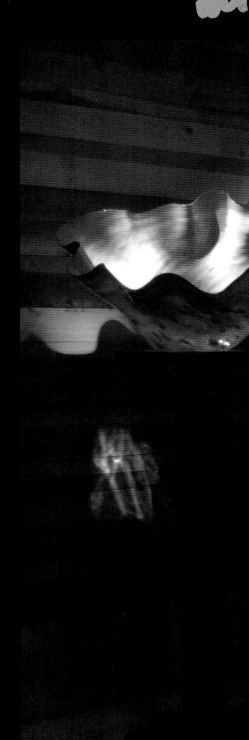

MACCHIA FOREST

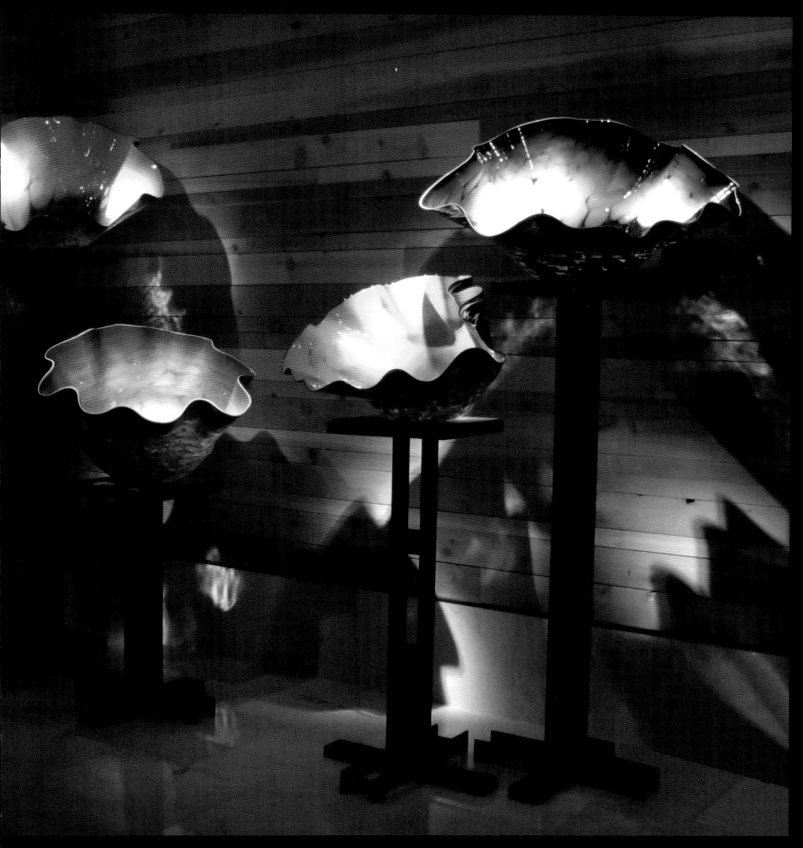

Macchia Forest
2010

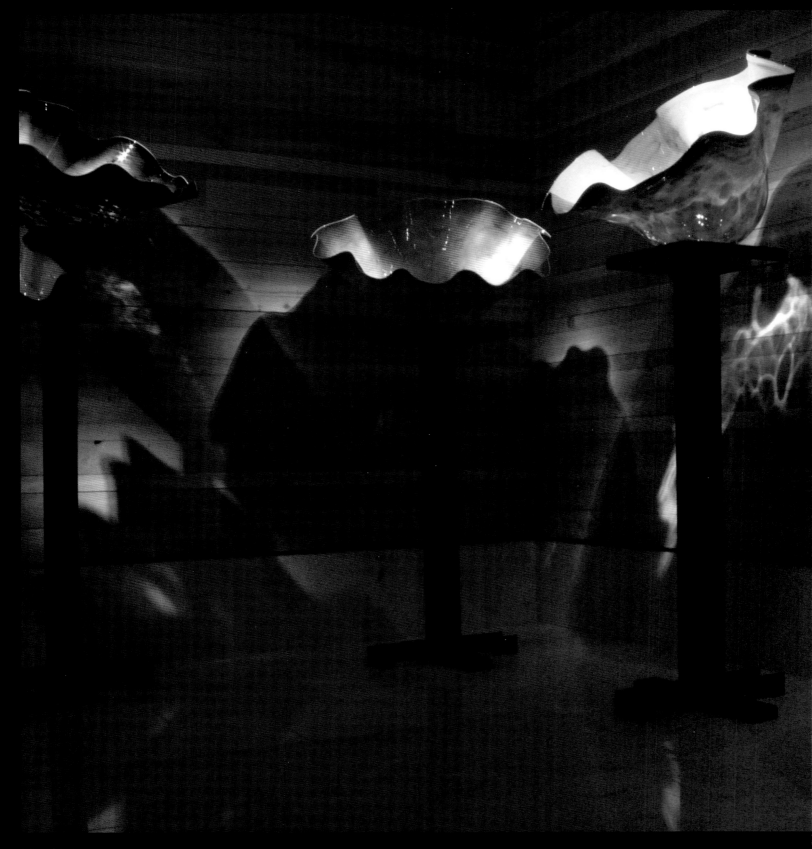

Macchia Forest
2010

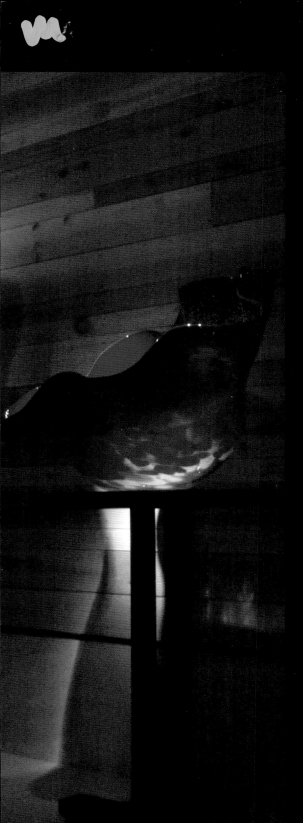

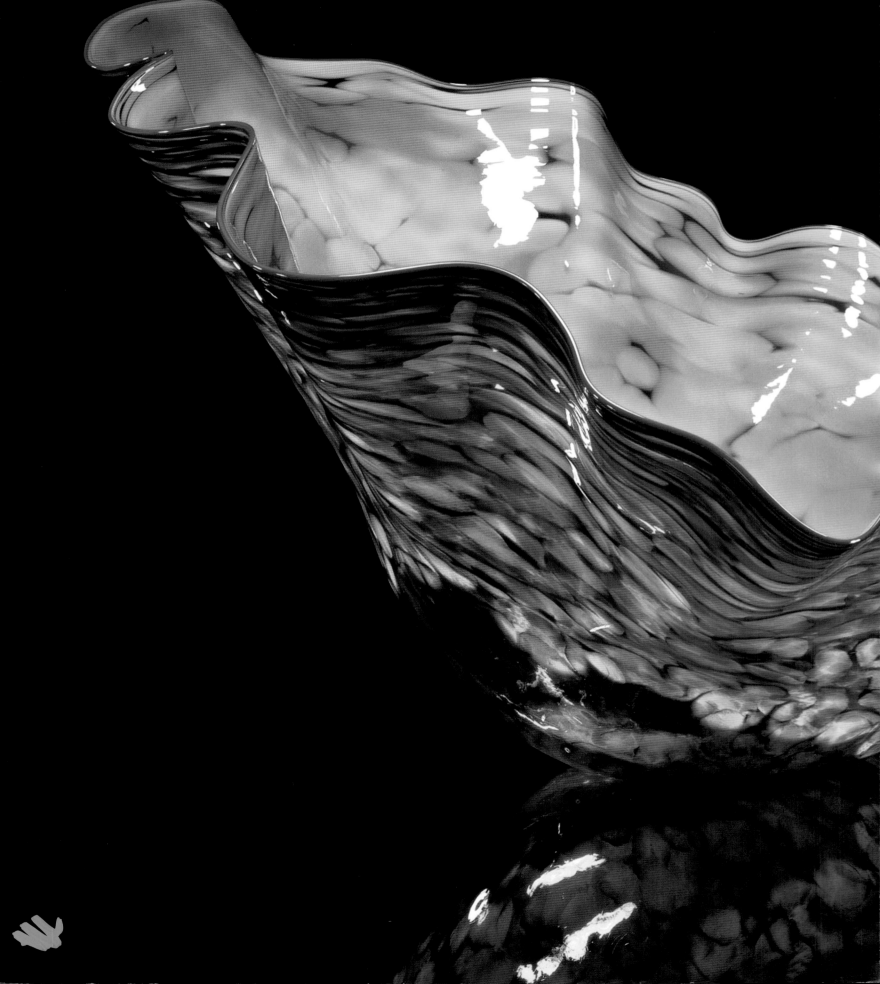

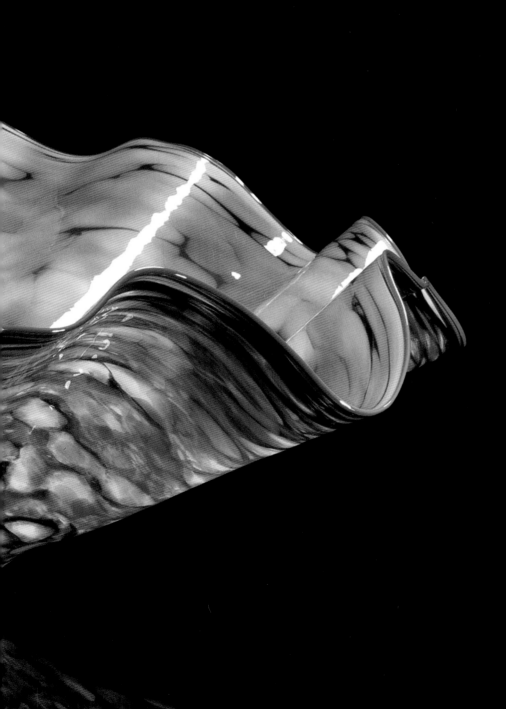

Caramel Macchia with Mineral Blue Lip Wrap
2007, 21 x 37 x 32"

Norse Blue Macchia with Cardinal Lip Wrap
2007, 23 x 36 x 31"

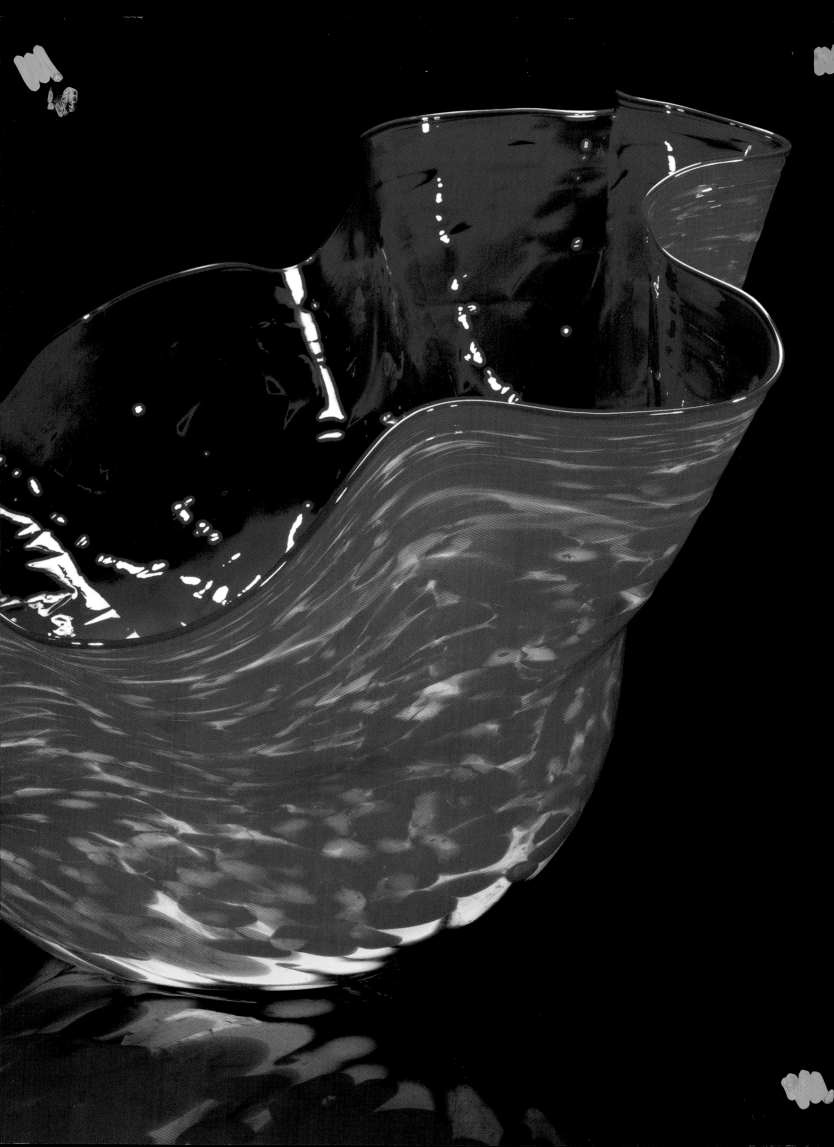

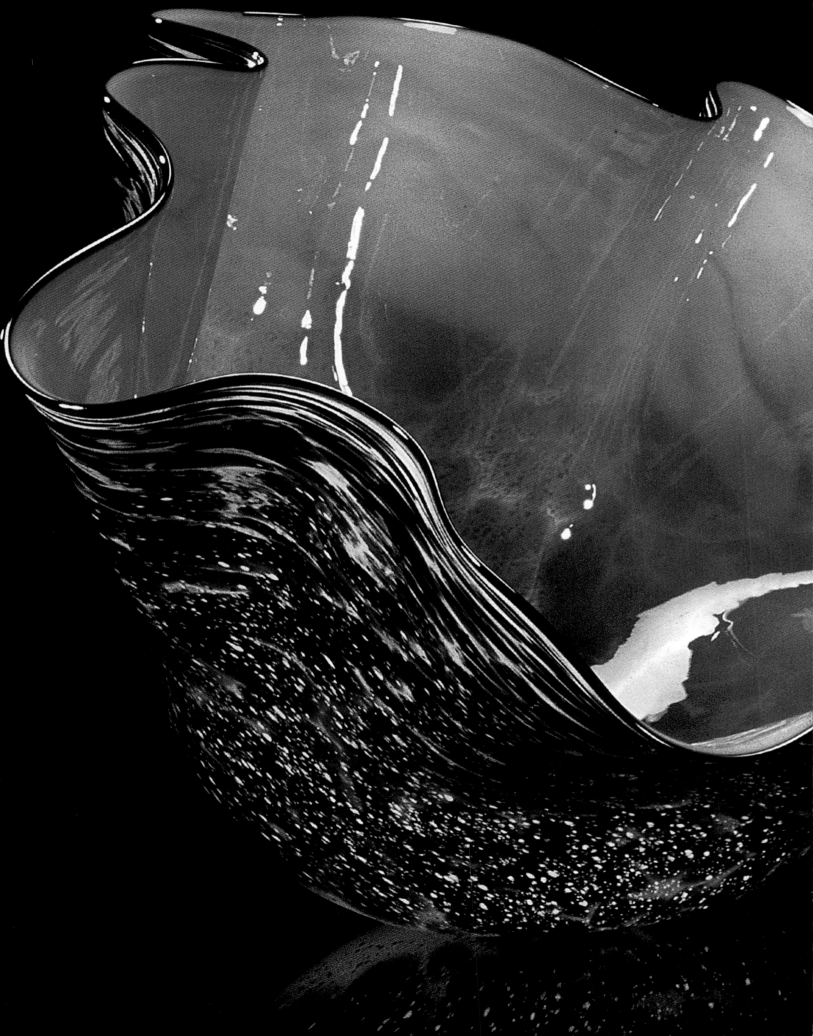

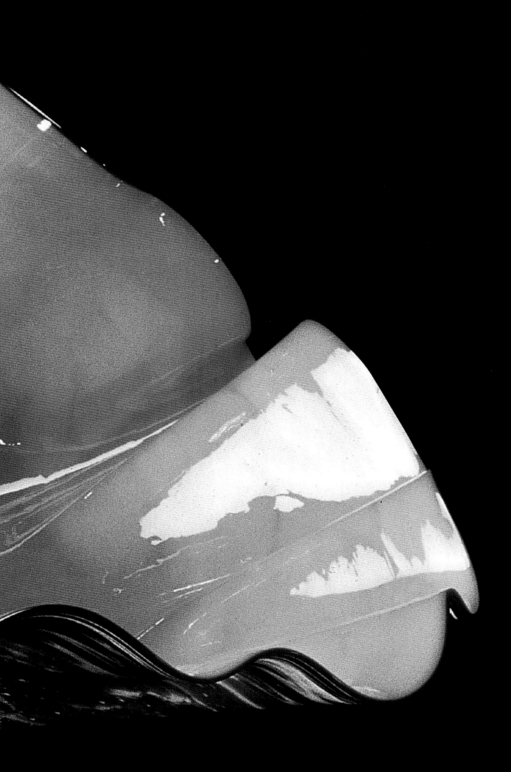

Spanish Orange Black Macchia with Sable Lip Wrap
2006, 19 x 36 x 25"

IKEBANA

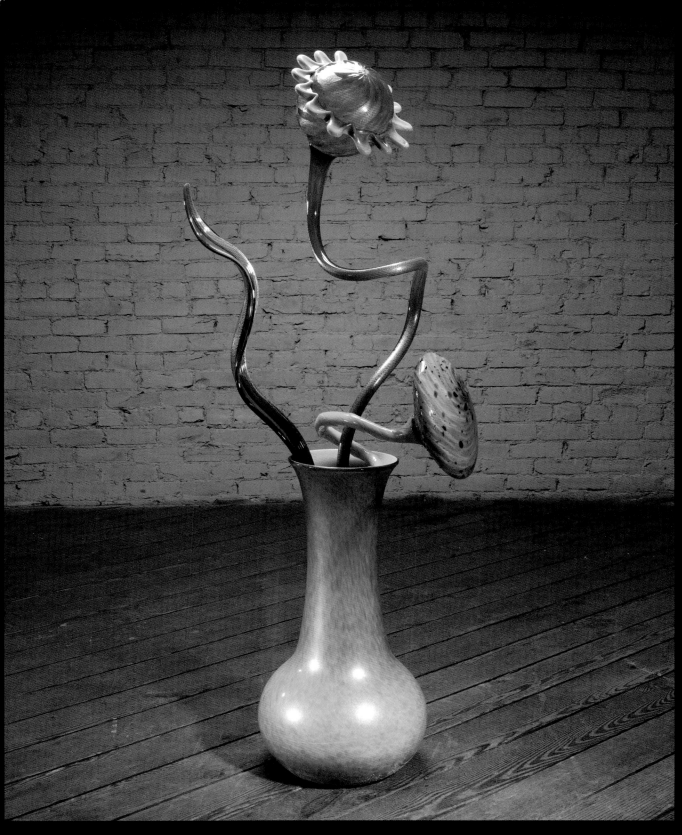

Verdant Green Ikebana with Emerald Leaf and Two Stems
2002, 58 x 23 x 21"

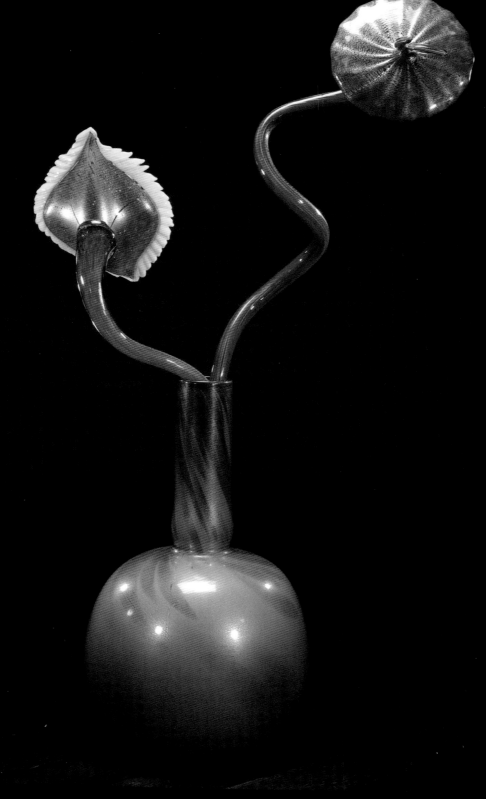

Muted Raspberry Ikebana with Gilded Pink Stems
2002, 53 x 23 x 16"

Silvered White-Spotted Ikebana with Gilded Purple Stems
2009, 53 x 39 x 28"

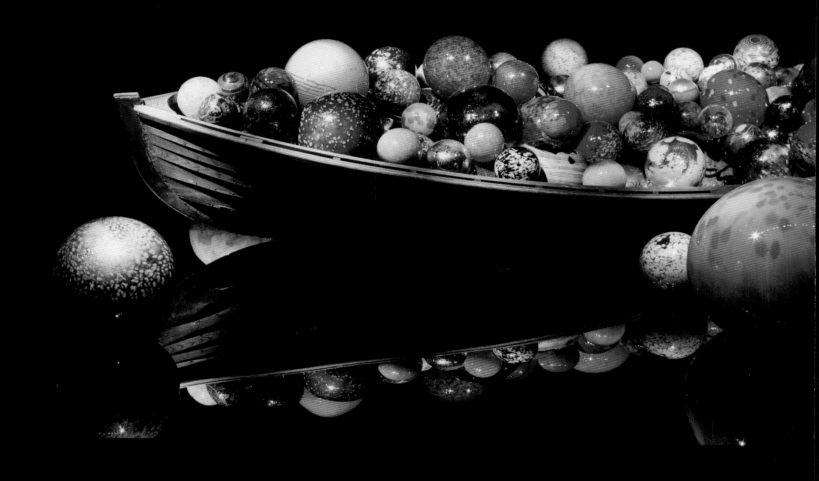

Float Boat
2010, 3 x 4½ x 12'

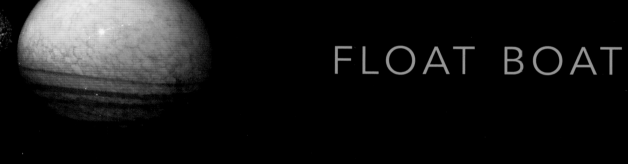

FLOAT BOAT

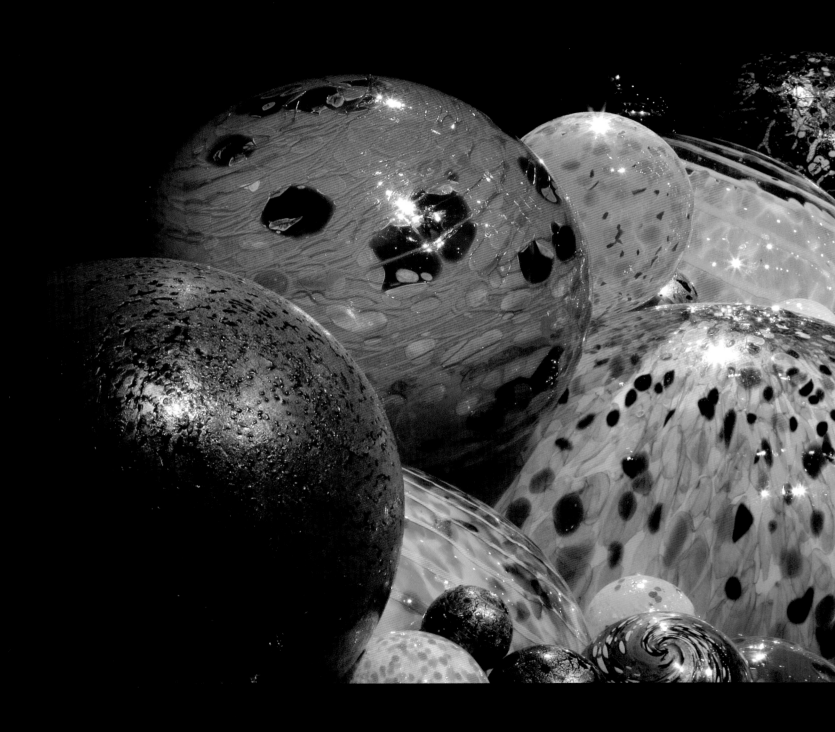

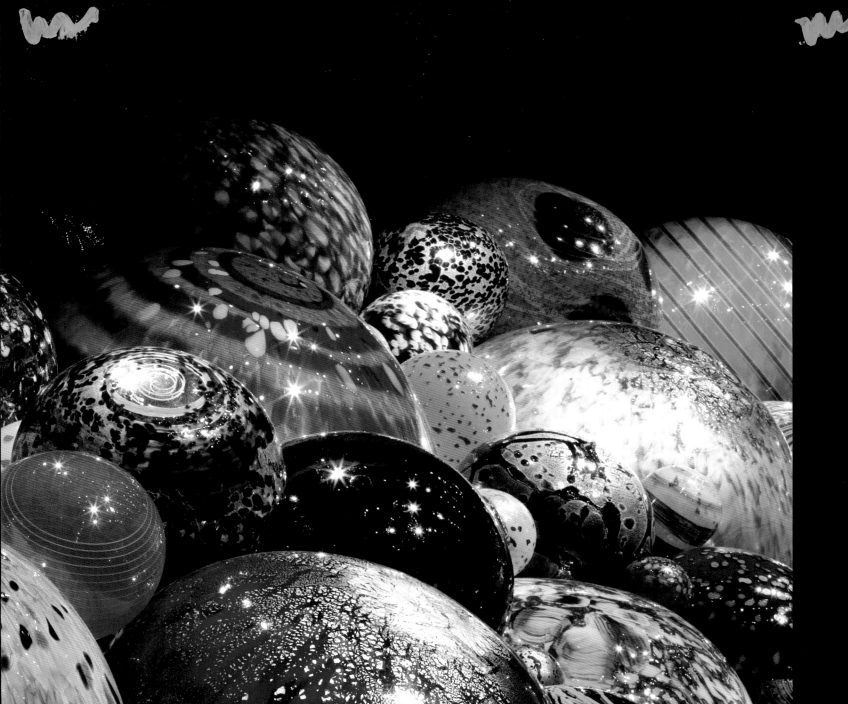

Niijima Floats (detail)

PERSIAN CEILING

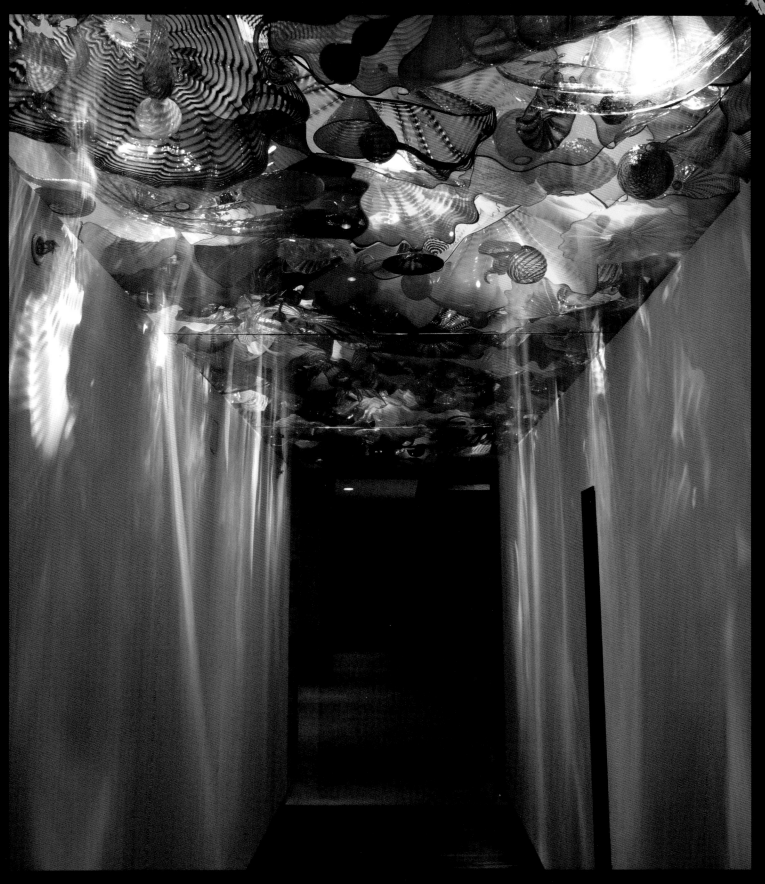

Persian Ceiling
2010

85

Seattle Art Museum Persian Ceiling Drawing
1992, 30 x 22"

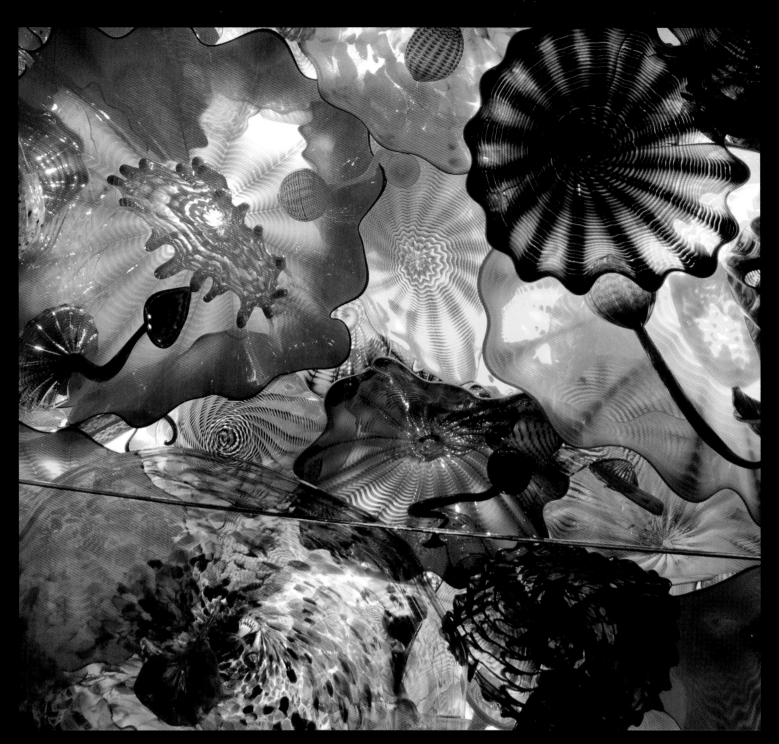

Persian Ceiling (detail)
2010

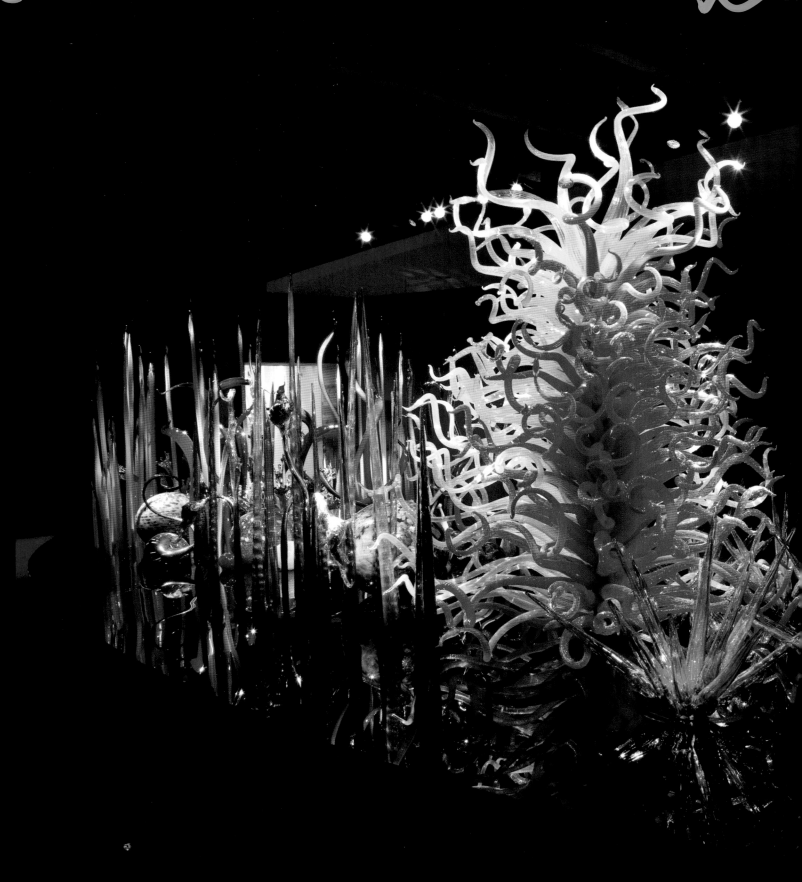

Mille Fiori
2010, 10½ x 33½ x 10½'

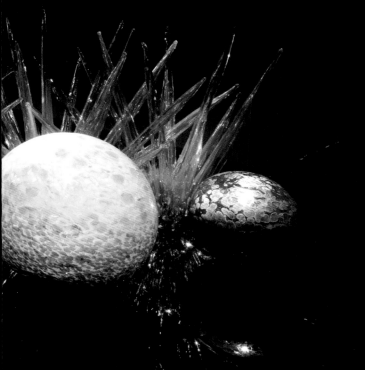

MILLE FIORI

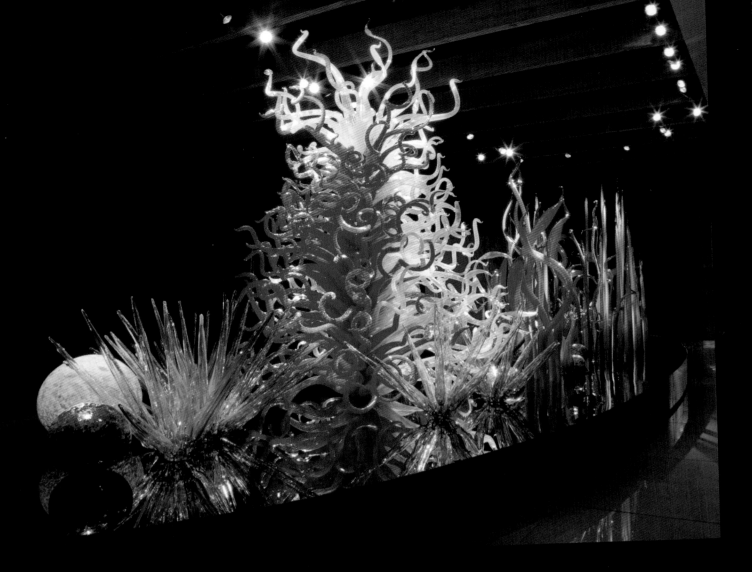

Mille Fiori
2010, 10½ x 33½ x 10½'

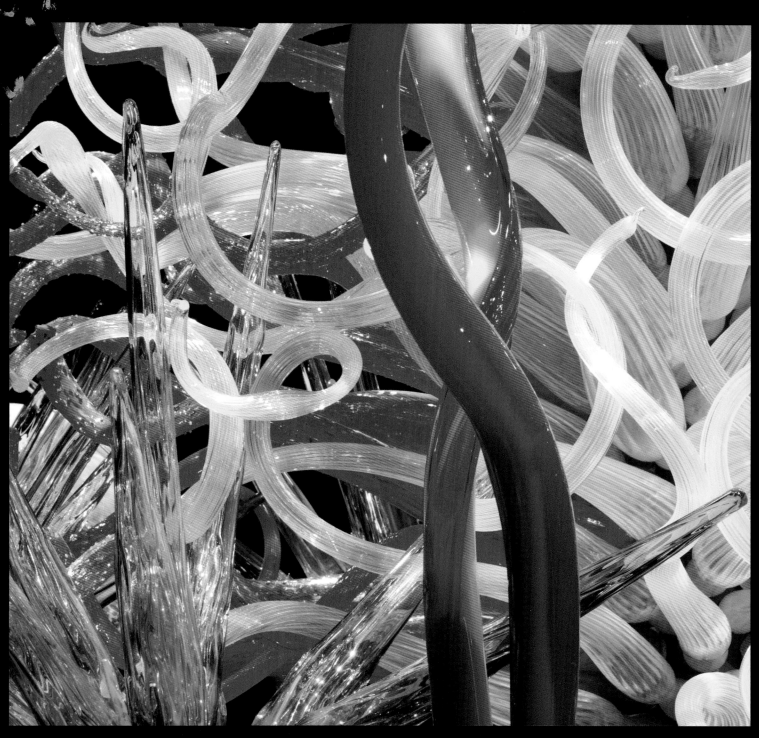

Mille Fiori (detail)
2010, 10½ x 33½ x 10½'

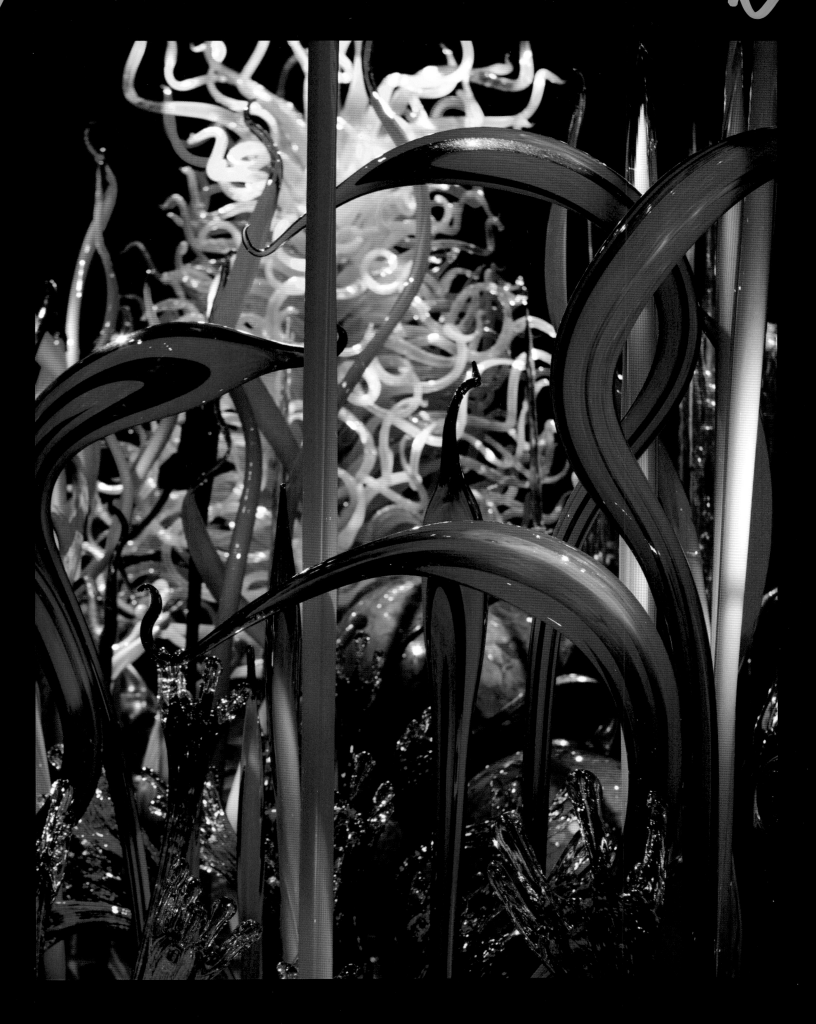

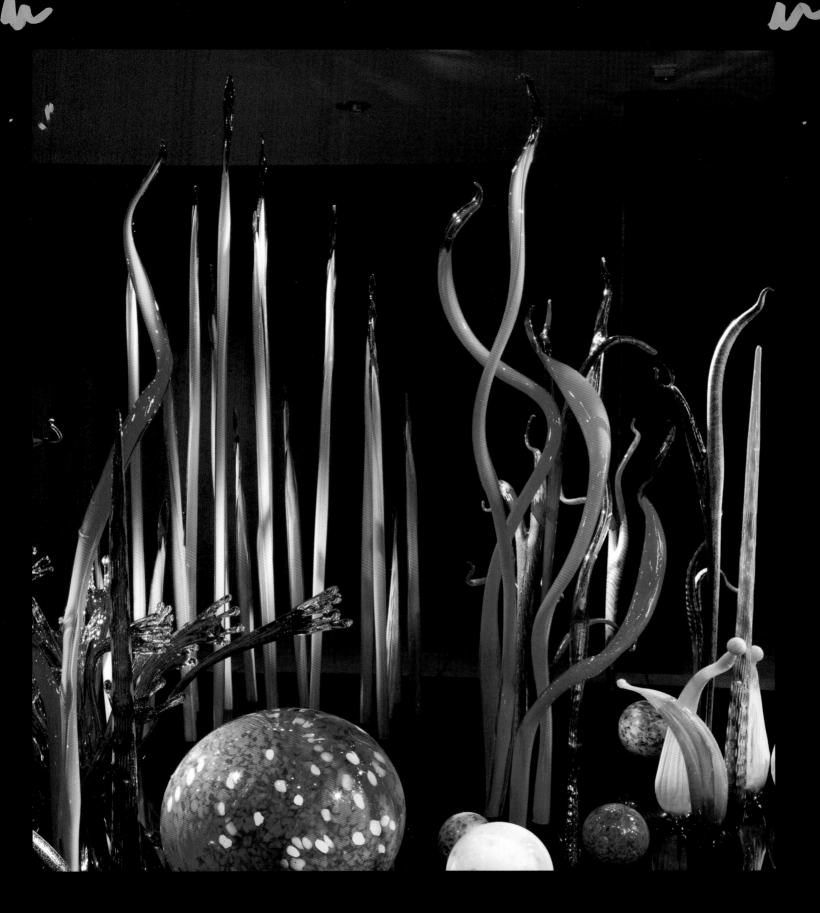

Mille Fiori (detail)
2010, 10½ x 33½ x 10½'

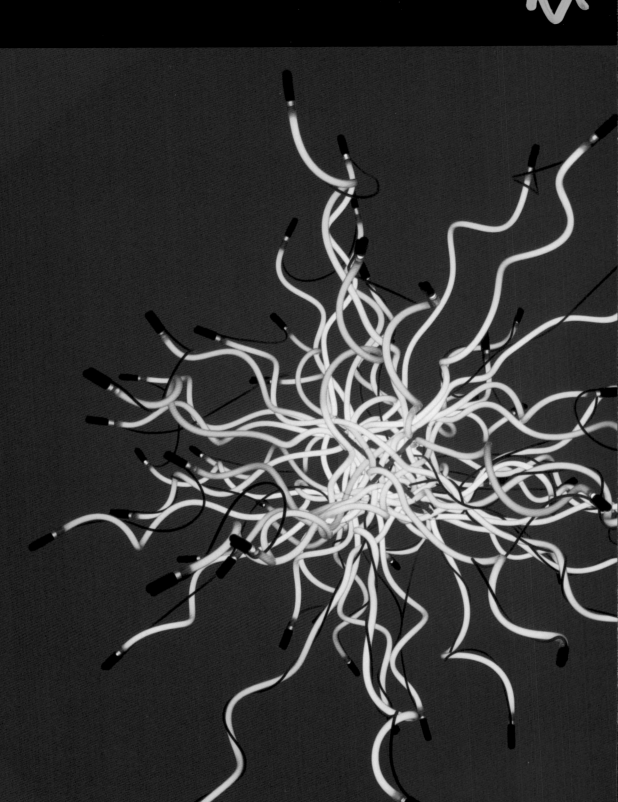

Blue Neon Tumbleweed
2010, 5 x 5 x 8'

NEON
TUMBLEWEED

Thank you to our generous
community, which has made the
Chihuly Collection possible.

Katee Tully

CHRONOLOGY

1941 Born September 20 in Tacoma, Washington, to George Chihuly and Viola Magnuson Chihuly.

1957 Older brother and only sibling, George, is killed in a Naval Air Force training accident in Pensacola, Florida.

1958 His father suffers a fatal heart attack at age 51. His mother goes to work to support Dale and herself.

1959 Graduates from high school in Tacoma. Enrolls in the College of Puget Sound (now the University of Puget Sound) in his hometown. Transfers to the University of Washington in Seattle to study interior design and architecture.

1961 Joins Delta Kappa Epsilon fraternity and becomes rush chairman. Learns to melt and fuse glass.

1962 Disillusioned with his studies, he leaves school and travels to Florence to study art. Discouraged by not being able to speak Italian, he leaves and travels to the Middle East.

1963 Works on a kibbutz n the Negev Desert. Returns to the University of Washington in the College of Arts and Sciences and studies under Hope Foote and Warren Hill. In a weaving class with Doris Brockway, he incorporates glass shards into woven tapestries.

1964 Returns to Europe, visits Leningrad, and makes the first of many trips to Ireland.

1965 Receives B.A. in Interior Design from the University of Washington. Experimenting on his own in his basement studio, Chihuly blows his first glass bubble by melting stained glass and using a metal pipe.

1966 Works as a commercial fisherman in Alaska to earn money for graduate school. Enters the University of Wisconsin at Madison, where he studies glassblowing under Harvey Littleton.

1967 Receives M.S. in Sculpture from the University of Wisconsin. Enrolls at the Rhode Island School of Design (RISD) in Providence, where he begins his exploration of environmental works using neon, argon, and blown glass. Awarded a Louis Comfort Tiffany Foundation Grant for work in glass. Italo Scanga, then on the faculty at Pennsylvania State University's Art Department, lectures at RISD, and the two begin a lifelong friendship.

1968 Receives M.F.A. in Ceramics from RISD. Awarded a Fulbright Fellowship, which enables him to travel and work in Europe. Becomes the first American glassblower to work in the Venini factory on the island of Murano. Returns to the United States and spends four consecutive summers teaching at Haystack Mountain School of Crafts in Deer Isle, Maine.

1969 Travels again throughout Europe and meets glass masters Erwin Eisch in Germany and Jaroslava Brychtová and Stanislav Libenský in Czechoslovakia. Returning to the United States, Chihuly establishes the glass program at RISD, where he teaches for the next fifteen years.

1970 Meets James Carpenter, a student in the RISD Illustration Department, and they begin a four-year collaboration.

1971 On the site of a tree farm owned by Seattle art patrons Anne Gould Hauberg and John Hauberg, the Pilchuck Glass School experiment is started. Chihuly's first environmental installation at Pilchuck is created that summer. He resumes teaching at RISD and creates *20,000 Pounds of Ice and Neon*, *Glass Forest #1*, and *Glass Forest #2* with James Carpenter, installations that prefigure later environmental works by Chihuly.

1972 Continues to collaborate with Carpenter on large-scale architectural projects. They create *Rondel Door* and *Cast Glass Door* at Pilchuck. Back in Providence, they create *Dry Ice, Bent Glass and Neon*, a conceptual breakthrough.

1974 Supported by a National Endowment for the Arts grant at Pilchuck, James Carpenter, a group of students, and he develop a technique for picking up glass thread drawings. In December at RISD, he completes his last collaborative project with Carpenter, *Corning Wall*.

1975 At RISD, begins series of *Navajo Blanket Cylinders*. Kate Elliott and, later, Flora C. Mace fabricate the complex thread drawings. He receives the first of two National Endowment for the Arts Individual Artist grants. Artist-in-residence with Seaver Leslie at Artpark, on the Niagara Gorge, in New York State. Begins *Irish Cylinders* and *Ulysses Cylinders* with Leslie and Mace.

1976 An automobile accident in England leaves him, after weeks in the hospital and 256 stitches in his face, without sight in his left eye and with permanent damage to his right ankle and foot. After recuperating he returns to Providence to serve as head of the Department of Sculpture and the Program in Glass at RISD. Henry Geldzahler, curator of contemporary art at the Metropolitan Museum of Art in New York, acquires three *Navajo Blanket Cylinders* for the museum's collection. This is a turning point in Chihuly's career, and a friendship between artist and curator commences.

1977 Inspired by Northwest Coast Indian baskets he sees at the Washington State Historical Society in Tacoma, begins the *Basket* series at Pilchuck over the summer, with Benjamin Moore as his gaffer. Continues his bicoastal teaching assignments, dividing his time between Rhode Island and the Pacific Northwest.

1978 Meets William Morris, a student at Pilchuck Glass School, and the two begin a close, eight-year working relationship. A solo show curated by Michael W. Monroe at the Renwick Gallery, Smithsonian Institution, in Washington, D.C., is another career milestone.

1979 Dislocates his shoulder in a bodysurfing accident and relinquishes the gaffer position for good. William Morris becomes his chief gaffer for the next several years. Chihuly begins to make drawings as a way to communicate his designs.

1980 Resigns his teaching position at RISD. He returns there periodically during the 1980s as artist-in-residence. Begins *Seaform* series at Pilchuck in the summer and later, back in Providence, returns to architectural installations with the creation of windows for the Shaare Emeth Synagogue in St. Louis, Missouri.

1981 Begins *Macchia* series.

1982 First major catalog is published: *Chihuly Glass*, designed by RISD colleague and friend Malcolm Grear.

1983 Returns to the Pacific Northwest after sixteen years on the East Coast. Works at Pilchuck in the fall and winter, further developing the *Macchia* series with William Morris as chief gaffer.

1984 Begins work on the *Soft Cylinder* series, with Flora C. Mace and Joey Kirkpatrick executing the glass drawings.

1985 Begins working hot glass on a larger scale and creates several site-specific installations.

1986 Begins *Persian* series with Martin Blank as gaffer, assisted by Robbie Miller. With the opening of *Objets de Verre* at the Musée des Arts Décoratifs, Palais du Louvre, in Paris, he becomes one of only four American artists to have had a one-person exhibition at the Louvre.

1987 Establishes his first hotshop in the Van de Kamp Building near Lake Union, Seattle. Begins association with artist Parks Anderson. Marries playwright Sylvia Peto.

1988 Inspired by a private collection of Italian Art Deco glass, Chihuly begins *Venetian* series. Working from Chihuly's drawings, Lino Tagliapietra serves as gaffer.

1989 With Italian glass masters Lino Tagliapietra, Pino Signoretto, and a team of glassblowers at Pilchuck Glass School, begins *Putti* series. Working with Tagliapietra, Chihuly creates *Ikebana* series, inspired by his travels to Japan and exposure to ikebana masters.

1990 Purchases the historic Pocock Building located on Lake Union, realizing his dream of being on the water in Seattle. Renovates the building and names it The Boathouse, for use as a studio, hotshop, and archives. Travels to Japan.

1991 Begins *Niijima Float* series with Richard Royal as gaffer, creating some of the largest pieces of glass ever blown by hand. Completes a number of architectural installations. He and Sylvia Peto divorce.

1992 Begins *Chandelier* series with a hanging sculpture at the Seattle Art Museum. Designs sets for Seattle Opera production of Debussy's *Pelléas et Mélisande*.

1993 Begins *Piccolo Venetians* series with Lino Tagliapietra. Creates *100,000 Pounds of Ice and Neon*, a temporary installation in the Tacoma Dome, Tacoma, Washington.

1994 Creates five installations for Tacoma's Union Station Federal Courthouse. Hilltop Artists, a glassblowing program in Tacoma, Washington, for at-risk youths, is created by friend Kathy Kaperick and supported by Chihuly. Within two years the program partners with Tacoma Public Schools.

1995 *Chihuly Over Venice* begins with a glassblowing session in Nuutajärvi, Finland, and a subsequent blow at the Waterford Crystal factory, Ireland.

1996　*Chihuly Over Venice* continues with a blow in Monterrey, Mexico, and culminates with the installation of fourteen *Chandeliers* at various sites in Venice. Creates his first permanent outdoor installation, *Icicle Creek Chandelier.*

1997　Continues and expands series of experimental plastics he calls "Polyvitro." *Chihuly* is designed by Massimo Vignelli and copublished by Harry N. Abrams, Inc., New York, and Portland Press, Seattle. A permanent installation of Chihuly's work opens at the Hakone Glass Forest, Ukai Museum, in Hakone, Japan.

1998　Chihuly is invited to Sydney, Australia, with his team to participate in the Sydney Arts Festival. A son, Jackson Viola Chihuly, is born February 12 to Dale Chihuly and Leslie Jackson. Creates architectural installations for Benaroya Hall, Seattle; Bellagio, Las Vegas; and Atlantis, the Bahamas.

1999　Begins *Jerusalem Cylinder* series with gaffer James Mongrain in concert with Flora C. Mace and Joey Kirkpatrick. Mounts his most challenging exhibition: *Chihuly in the Light of Jerusalem 2000*, at the Tower of David Museum of the History of Jerusalem. Outside the museum, he creates a sixty-foot wall from twenty-four massive blocks of ice shipped from Alaska.

2000　Creates *La Tour de Lumière* sculpture as part of the exhibition *Contemporary American Sculpture* in Monte Carlo. Marlborough Gallery represents Chihuly. More than a million visitors enter the Tower of David Museum to see *Chihuly in the Light of Jerusalem 2000*, breaking the world attendance record for a temporary exhibition during 1999–2000.

2001　*Chihuly at the V&A* opens at the Victoria and Albert Museum in London. Exhibits at Marlborough Gallery, New York and London. Groups a series of *Chandeliers* for the first time to create an installation for the Mayo Clinic in Rochester, Minnesota. Artist Italo Scanga dies; he was a friend and mentor for more than three decades. Presents his first major glasshouse exhibition, *Chihuly in the Park: A Garden of Glass*, at the Garfield Park Conservatory, Chicago.

2002　Creates installations for the Salt Lake 2002 Olympic Winter Games. The *Chihuly Bridge of Glass*, conceived by Chihuly and designed in collaboration with Arthur Andersson of Andersson·Wise Architects, is dedicated in Tacoma, Washington.

2003　Begins the *Fiori* series with gaffer Joey DeCamp for the opening exhibition at the Tacoma Art Museum's new building. TAM designs a permanent installation for its collection of his works. *Chihuly at the Conservatory* opens at the Franklin Park Conservatory, Columbus, Ohio.

2004　Creates new forms in his *Fiori* series for an exhibition at Marlborough Gallery, New York. The Orlando Museum of Art and the Museum of Fine Arts, St. Petersburg, Florida, become the first museums to collaborate and present simultaneous major exhibitions of his work. Presents a glasshouse exhibition at Atlanta Botanical Garden.

2005 Marries Leslie Jackson. Mounts a major garden exhibition at the Royal Botanic Gardens, Kew, outside London. Shows at Marlborough Monaco and Marlborough London. Exhibits at the Fairchild Tropical Botanic Garden, Coral Gables, Florida.

2006 Mother, Viola, dies at the age of ninety-eight in Tacoma, Washington. Begins *Black* series with a *Cylinder* blow. Presents glasshouse exhibitions at the Missouri Botanical Garden and the New York Botanical Garden. *Chihuly in Tacoma*—hotshop sessions at the Museum of Glass—reunites Chihuly and glassblowers from important periods in his artistic development. The film *Chihuly in the Hotshop* documents this event.

2007 Exhibits at the Phipps Conservatory and Botanical Gardens, Pittsburgh. Creates stage sets for the Seattle Symphony's production of Béla Bartók's opera *Bluebeard's Castle*.

2008 Presents his most ambitious exhibition to date at the de Young Museum, San Francisco. Returns to his alma mater with an exhibition at the RISD Museum of Art. Exhibits at the Desert Botanical Garden in Phoenix.

2009 Begins *Silvered* series. Mounts a garden exhibition at the Franklin Park Conservatory, Columbus, Ohio. Participates in the 53rd Venice Biennale with a *Mille Fiori* installation. Creates largest commission with multiple installations on the island resort of Sentosa, Singapore.

COLOPHON

This first printing of **CHIHULY COLLECTION PRESENTED BY THE MOREAN ARTS CENTER** is limited to 5,000 perfectbound copies. © 2010 Portland Press. All rights reserved.

PHOTOGRAPHY

Parks Anderson, Jody Coleman, Jack Crane, David Emery, Claire Garoutte, Al Hurley, Russell Johnson, Scott M. Leen, Tom Lind, Teresa Nouri Rishel, Terry Rishel, and Charlie Wilkins

DESIGN

Janná Giles, Tina Kim, and Billy O'Neill

TYPEFACE

Avenir

PRINTING

Printed and bound in China by Global PSD

Portland Press
Post Office Box 70856
Seattle, WA 98127
800 574 7272
www.portlandpress.net
ISBN: 978-1-57684-037-5

morean artscenter
ST. PETERSBURG, FLORIDA
719 Central Avenue
St. Petersburg, FL 33701
727 822 7872
www.moreanartscenter.org

FRONT COVER:
Tabac Basket with Drawing Shards and Oxblood Body Wrap
2008, 14 x 11 x 12"

OPPOSITE TITLE PAGE:
Florida Rose Crystal Tower
2010, 21½ x 5 x 4½'